REGULATION

REGULATION:
A PRIMER

Second Edition

by Susan E. Dudley and Jerry Brito

MERCATUS CENTER
George Mason University

THE GEORGE WASHINGTON UNIVERSITY
WASHINGTON DC
REGULATORY STUDIES CENTER

Mercatus Center
George Mason University
3351 North Fairfax Drive, 4th Floor
Arlington, VA 22201-4433
T: (703) 993-4930
mercatus.org

The George Washington University Regulatory Studies Center
805 21st Street, NW
Media and Public Affairs Building 612
Washington, DC 20052
T: (202) 994-7543 F: (202) 994-6792
regulatorystudies.gwu.edu

Library of Congress Cataloging-in-Publication Data

Dudley, Susan E.
 Regulation : a primer / by Susan E. Dudley and Jerry Brito.
 p. cm.
 ISBN 978-0-9836077-3-1
 1. Administrative procedure--United States. 2. Administrative
agencies--United States--Decision making. 3. Administrative regulation
drafting--United States. I. Brito, Jerry. II. Title.
 KF5411.D83 2012
 342.73'06--dc23
 2012026565

First printing, August 2012
Printed in the United States of America

CONTENTS

"Whenever competition is feasible, it is, for all its imperfections, superior to regulation as a means of serving the public interest."

—*Alfred Kahn*

1

WHAT IS REGULATION?

R EGULATIONS, ALSO CALLED administrative laws or rules, are the primary vehicles by which the federal government implements laws and agency objectives. They are specific standards or instructions concerning what individuals, businesses, and other organizations can or cannot do.

Market economies need clear rules to function efficiently. Without a legal framework establishing and enforcing property rights and the "rules of the game," our free enterprise system could not exist. Regulations issued by the executive branch affect every aspect of our lives. From the moment you wake up until the time you go to sleep, regulations influence what you do. Yet most people know very little about the impact of regulations or the process by which they are produced.

This primer provides an overview of federal regulation, covering theory, policy, analysis, and practice. We begin with a look at a day in the life of a regulated American family. Then, this first chapter presents statistics on the size and scope of regulation and classifies regulations into basic categories

for subsequent discussion. Chapter 2 explores theories of regulation, while chapter 3 reviews the constitutional underpinnings of executive branch regulation. Chapter 4 describes the process by which the federal government develops regulations, and chapter 5 examines who the regulators are and what incentives they face. Chapters 6 and 7 delve into the nature of regulations, particularly those addressing health, safety, the environment, and specific industries. In chapter 8, we roll up our sleeves and analyze regulations to understand what makes for good policy. Chapter 9 concludes with a brief look at future trends in regulation.

A DAY IN THE LIFE OF A REGULATED AMERICAN FAMILY

WHAT DO YOU think of when you think of regulations?

You may think of rules like the Federal Trade Commission's Do Not Call regulations requiring telemarketers to honor people's preferences about receiving marketing phone calls in the middle of dinner, or perhaps you think of environmental regulations restricting emissions from power plants. You might be surprised to learn just how many regulations you encounter in an average day.

Perhaps your day starts when your clock radio goes off in the morning. The Federal Communications Commission (FCC) regulates not only the airwaves used by your favorite radio station, but also the programming content. Electricity regulated by the Federal Energy Regulatory Commission (FERC) and by state regulatory agencies powers your radio. The U.S. Department of Energy (DOE) regulates the type of light bulb you can use in your lamp.

The Consumer Product Safety Commission regulates the label on your mattress. The Food and Drug Administration (FDA) regulates the content of your toothpaste, soap, shampoo, and other grooming products. The Environmental Protection

Agency (EPA) regulates the quality of the water coming out of your showerhead. On your way out of the bathroom, you may have to flush your low-flow toilet twice, a result of mandates imposed by the DOE's appliance efficiency rules.

As you prepare your breakfast, you might check your cereal's FDA-regulated label for nutritional information. The FDA also regulates what companies may say about the health benefits of foods and what adjectives they may use to describe those health benefits. The FDA and U.S. Department of Agriculture (USDA) have a hand in regulating your coffee and sugar. Also joining you for your cup of java is the Commodity Futures Trading Commission, which regulates the hedging of investments in coffee beans, sugar, and other commodities.

The EPA, FDA, and USDA Animal and Plant Health Inspection Service regulate the fruit you serve for breakfast. The USDA's Agricultural Marketing Service also plays a role in your breakfast. It sets grade standards and purchases fruits and vegetables "to correct supply and demand imbalances," which keeps prices higher than they otherwise would be. The USDA even regulates the size of the holes in the Swiss cheese you grate into your omelet.

As you head off to school and work, you might put your children in the back seat because the passenger air bags required by the National Highway Traffic Safety Administration (NHTSA) have killed children and small adults riding in the front. Your car is also subject to the NHTSA's and EPA's fuel economy standard and the EPA's emission standards. If you do not have a carpool, you may have to take a roundabout way to your office because the most direct route is reserved for "high occupancy vehicles" during the morning rush hour. The EPA's air quality state implementation plans, or SIPs, mandate that states set aside roads for carpools or forfeit federal highway funds. If your day involves air travel, you will be subjected to passenger

screening and other Department of Homeland Security (DHS) requirements at the airport.

At work, regulations issued by the Department of Labor (DOL) may keep your workplace safer, but they may also limit the arrangements you can agree upon with your employer. Mandated employee benefits standards may prevent employees from negotiating the benefit packages that best suit their individual needs and preferences, so you may be unwittingly forced to accept lower wages in exchange for benefits you do not want. Regulations guarantee you a minimum wage for your work, but they discourage employers from hiring younger or less-experienced workers. The health care plans you can choose from and their terms are regulated by the Department of Health and Human Services or your state government, while the retirement savings plan options available to you are governed by DOL and Securities and Exchange Commission (SEC) rules.

When you stop by the store on your way home from work, regulations covering product safety, food, pharmaceuticals, and the environment affect the character, availability, and price of the products you buy. These rules may keep some unsafe products off the market, but they also raise prices and may prevent valuable and potentially life-saving new products from becoming available to Americans.

Back at home in the evening, you might unwind in front of the television with a glass of wine. The local news program you watch exists in part to comply with public interest obligations the FCC imposes as a condition of licensing stations. There are health benefits to moderate alcohol consumption, but you won't find that information on the label because the Alcohol and Tobacco Tax and Trade Bureau prohibits winemakers from telling you so. Later, you might help your children study for a standardized test that—under Department of Education regulations—will affect local school funding.

Regulation touches our everyday lives in thousands of ways that we may never imagine. These rules have both benefits and costs, but most people are unaware of their reach and influence. This primer aims to make the complicated and arcane world of regulation more understandable to interested people outside the Washington, DC, beltway.

ESTIMATING THE SCOPE OF FEDERAL REGULATION

TAXING AND SPENDING is one way the federal government diverts resources from the private sector to accomplish public goals. Regulation of private entities—businesses, workers, and consumers—is another.

Over 70 federal departments, agencies, and commissions employ a combined staff of almost 300,000 full-time employees to write and enforce federal regulations. Together they issue thousands of new rules each year. The desired benefits of regulation are the force behind the legislative initiatives that create them, and discussions tend to focus on these goals rather than on the costs of achieving them.

Unlike the fiscal budget, which tracks direct government spending supported by taxes, there is no mechanism for keeping track of the spending by individuals and businesses that results from regulatory compliance. Thus, efforts to track changes in regulatory activity over time often depend on proxies such as the number of pages printed in the *Federal Register* or the size of regulatory agencies' budgets.

The *Code of Federal Regulations* is the compilation of all rules and regulations enacted by federal agencies. Its size (which has grown from under 25,000 pages to over 165,000 pages over the last 50 years) provides a sense of the scope of existing regulations with which American businesses, workers, and consumers must comply.

The number of pages in the *Federal Register*—the daily journal of the federal government in which all newly proposed rules are published, along with final rules, executive orders, and other agency notices—provides a sense of the flow of new regulations issued during a given period and suggests how the regulatory burden will grow as Americans try to comply with the new mandates. In 2011, the federal government printed 82,129 pages of rules and announcements in the *Federal Register*. At a reading rate of 4 minutes per page, 2.6 people would have to read for 40 hours per week for a year just to keep up with the new rules and pronouncements. Figure 1.1 shows the growth in the number of pages in the *Federal Register* over time.

FIGURE 1.1: ANNUAL PAGES PUBLISHED IN THE FEDERAL REGISTER

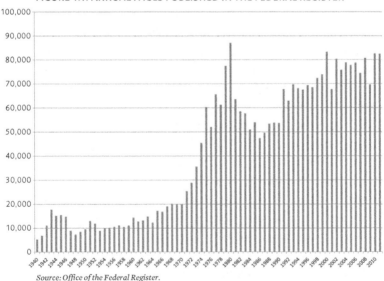

Source: Office of the Federal Register.

Another proxy for the scope of regulatory activity is the direct fiscal budget expenditures devoted to regulatory agencies. By analyzing the federal personnel and expenses

necessary to develop and enforce regulations, we can track regulatory trends over time. These data provide insight into the composition and evolution of regulation. Figure 1.2 shows the growth from 1960 to 2013 in the portion of the federal budget devoted to writing and enforcing regulations.[1]

FIGURE 1.2: BUDGETARY COSTS OF FEDERAL REGULATION, ADJUSTED FOR INFLATION

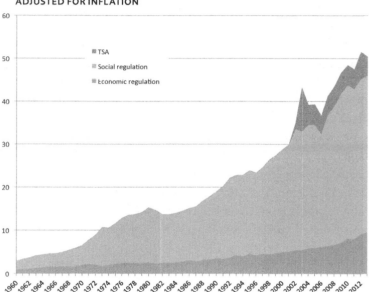

Source: Susan Dudley and Melinda Warren, Growth in Regulators' Budget Slowed by Fiscal Stalemate: An Analysis of the U.S. Budget for Fiscal Years 2012 and 2013, *Regulators' Budget Report 34 (St. Louis and Washington, DC: Weidenbaum Center at Washington University and George Washington University Regulatory Studies Center, July 2012), http://regulatorystudies.gwu.edu/images/commentary/regulators_budget_2012.pdf. Derived from the Budget of the United States Government and related documents, various fiscal years.*

Regulations provide social benefits and impose social costs on individuals and businesses beyond the direct tax dollars expended to write and enforce them. *Federal Register* pages,

1. These data focus on regulations that affect private sector activity and exclude the regulation of taxation, entitlement, procurement, subsidy, and credit functions. Figures for 2012 and 2013 are estimates based on the president's budget request to Congress.

agency staffing, and on-budget costs are merely proxies of these effects. The social costs of federal regulations are enormously difficult to measure. A 2010 Small Business Administration study was one of the few efforts to develop a comprehensive estimate, but its methodology has been questioned. It put total regulatory costs at $1.75 trillion per year and average household regulatory expenditures at $15,500 per year.[2]

The Office of Information and Regulatory Affairs (OIRA) in the Office of Management and Budget (OMB) has kept a running total of the benefits, as well as the costs, of the major regulations issued during the previous 10 years. In its draft 2012 report, OIRA estimates the cost of major regulations issued from 2001 to 2011 at $43 to $67 billion per year and the benefits at $141 to $700 billion per year. The OMB recognizes that its estimates likely understate regulatory impacts for a couple of reasons. First, they exclude certain costs, deemed transfers (discussed more in chapter 6). Second, they cover only executive branch agency regulations with annual impacts of $100 million or more issued over the last decade and for which agencies estimated both costs and benefits. For example, the OMB bases benefits and costs for fiscal year 2011 on agency estimates for only 13 regulations, or 0.5 percent of the final rules published in the *Federal Register* during that year.

CATEGORIES OF REGULATION

WE OFTEN DIVIDE regulations into two main categories: social regulations and economic regulations. Social regulations address issues related to health, safety, security, and the environment. The EPA, Occupational Safety and Health Administation (OSHA), the FDA, and the DHS are examples

2. Nicole V. Crain and W. Mark Crain, *The Impact of Regulatory Costs on Small Firms* (Washington, DC: SBA Office of Advocacy, September 2010), http://archive.sba.gov/advo/research/rs371tot.pdf.

of agencies that administer social regulations. Their activities are generally limited to a specific issue, but they also have the power to regulate across industry boundaries. For example, OSHA regulates worker safety across industries. Chapter 7 discusses social regulations.

Economic regulations are often industry-specific. The SEC, the FCC, FERC, and the new Consumer Financial Protection Bureau (CFPB) are examples of agencies that administer economic regulations. Economic regulation usually governs a broad base of activities in particular industries, using economic controls such as price ceilings or floors, production quantity restrictions, and service parameters. For example, FERC employs these tools to regulate the wholesale electricity markets, where many local electric companies buy at least some of their power. Chapter 6 addresses economic regulations in more detail.

FURTHER READING

Nicole V. Crain and W. Mark Crain. *The Impact of Regulatory Costs on Small Firms.* Washington, DC: SBA Office of Advocacy, September 2010. http://archive.sba.gov/advo/research/rs371tot.pdf.

Susan Dudley and Melinda Warren. *Growth in Regulators' Budget: An Analysis of the U.S. Budget for Fiscal Years 2012 and 2013.* Regulators' Budget Report 34. St. Louis and Washington, DC: Weidenbaum Center at Washington University and Regulatory Studies Center at George Washington University, July 2012. http://regulatorystudies.gwu.edu/images/commentary/regulators_budget_2012.pdf.

Office of Management and Budget. *2011 Report to Congress on the Benefits and Costs of Federal Regulations and Unfunded Mandates on State, Local, and Tribal Entities.* Washington, DC: OMB, 2011. http://www.whitehouse.gov/sites/default/files/omb/inforeg/2011_cb/2011_cba_report.pdf.

Clyde Wayne Crews Jr. *Ten Thousand Commandments: An Annual Snapshot of the Federal Regulatory State.* Washington, DC: Competitive Enterprise Institute, 2012. http://cei.org/studies/ten-thousand-commandments-2012.

2

THEORIES OF REGULATION:
WHY DO WE REGULATE?

I N A FREE-MARKET economy like that of the United States, why does the government regulate the behavior of firms and individuals? What factors affect the number and extent of regulations, and what motivates individual regulations? The answers to these questions come from theories, or models, of how institutions, businesses, and individuals behave and from empirical analyses and observations.

Before we delve into the different theories, we must distinguish between normative and positive analysis. Normative analysis examines *what should be*. In the case of regulation, it asks when the government *should* intervene in private markets. Positive analysis, on the other hand, examines *what is*. Positive theories try to explain when regulation will occur and why we see certain types of regulations in some industries and not others. This chapter will focus on positive theories of regulation. We address normative analysis in chapter 8.

PUBLIC INTEREST THEORY

OUR UNDERSTANDING OF why we have regulation has evolved over time and has incorporated economics and theories of human behavior. The "public interest" theory of regulation recognizes that markets are very efficient at allocating scarce resources to their best uses. It is based on a normative notion that government intervention may be appropriate, however, in cases when competitive conditions are not met and markets fail to allocate resources efficiently. The theory holds that politicians seeking to serve the public interest will regulate only to correct those market failures.

The concept of market failure comes from the economic paradigm of a perfectly competitive market, characterized by (1) private decisions, such that individual choices do not affect the welfare of others; (2) private goods; (3) market participants who are price takers; and (4) perfect information about price and quality. Welfare economists, led by British economist A. C. Pigou early in the 20th century, focused on the need for government intervention when markets deviate from these perfect market conditions.

Market failures generally fall into one of four categories.

- **Externalities** occur when one party's actions impose uncompensated costs or benefits on another party (violating the "private decisions" condition). If those actions affect the other party's welfare enough that the party would be willing to pay to alter them, then resources are not allocated the way they would be if all costs and benefits were "internalized" by some actor in the marketplace. Pollution is the classic example of an externality (as discussed in chapter 7).

- **Public goods** are those for which the cost of providing an additional unit is negligible and excluding users is costly (violating the "private goods" condition). National defense is the classic example of a pure public good: the cost of provision does not increase with an additional citizen, and once provided, it cannot be withheld from citizens who do not contribute to its cost. A related concept, common pool resources, shares the characteristic that exclusion is costly, though the marginal cost of production is not negligible. Common pool resources tend to be overused (as in overfishing) or underprovided (as in new medical discoveries, which might not be made if not for patents granting the discoverer rights to profit).

- The presence of **monopoly power** in a market allows a firm to control prices, violating the perfect market condition that all participants are "price takers." "Natural monopolies" exist when long-run declining costs make economies of scale so great that a market can be served at lowest cost only if production is limited to a single producer. Because the supplier doesn't face competition, however, without some form of intervention, prices would be higher and quantity produced lower than in a competitive market.

- Finally, when market participants have **asymmetric information**, markets may not allocate resources efficiently. The classic illustration is when a seller has information on a flaw in her product that she doesn't share with a buyer, leading the buyer to pay more (and purchase more) than he would if fully informed. The absence of perfect information in a transaction does not

in itself necessitate government intervention. Not only is perfect information impossible, it is not required for a well-functioning market.

When one of these market failures exists, a normative approach might argue that public-minded politicians should intervene to correct the market by either internalizing externalities, clarifying property rights, regulating monopolists, or providing information. Positive theory suggests that we should expect to see regulations enacted to address perceived or real market failures and thereby serve the public interest.

There are several problems with this public interest theory of regulation, however.

- As a positive theory, it hypothesizes that regulation *will* occur when it *should* because the net social gains will be greater with than without regulation, but it does not explain the mechanism by which such a solution would occur. In other words, it does not tell us how or why people, in their roles as government officials, businessmen, consumers, and so on, will produce the desired outcome.

- More importantly, public interest theory does not do a good job of predicting when we will see regulation. Many regulations do not correspond to market failures such as natural monopoly or externalities. For example, economic regulations are not well correlated with identifiable market failures, and they often seem to benefit the regulated industries by enforcing cartels rather than benefiting consumers by preventing monopoly. The now-abolished Interstate Commerce Commission, for example, enforced a cartel among railroads that kept prices above competitive levels.

This is not to say that regulations are never motivated by public interest goals, but rather to say the public interest theory fails to explain observed forms of regulation.

CAPTURE THEORY

OBSERVING THAT LAWS and regulations do not necessarily correspond to industries characterized by market failures, and that many regulations seem to serve private interests, political scientists and economists offered an alternative hypothesis. They suggested that politicians and regulators end up being "captured" by special interests, usually the producers they are intended to regulate. As a result, laws and regulations serve not the public interest, but those special interests.

While the capture theory better explains the occurrence of regulation than the public interest theory, it is incomplete. Many regulations do not appear to serve the industry being regulated. The capture theory fails to explain *why* regulators would get captured and by *whom*.

Two Nobel Prize-winning economists, George Stigler and James Buchanan (who collaborated with Gordon Tullock), as well as economist Mancur Olson, developed related theories that address these weaknesses in the capture theory: the theory of economic regulation and public choice theory.

THE ECONOMIC THEORY OF REGULATION

GEORGE STIGLER'S 1971 article "The Theory of Economic Regulation" offered a clear, testable theory that explained the presence of regulation in different industries. It also raised awareness of the incentives and wealth-redistribution consequences of economic regulation. Stigler started with the following premises:

1. Government's basic resource is the power to coerce.

2. An interest group that can convince the government to use its coercive power to the group's benefit can improve its well-being at the expense of others.

3. Agents (firms, individuals, government officials, and interest groups) are rational and try to maximize their own utility (well-being).

With this foundation, he hypothesized that regulation is supplied in response to the demands of interest groups acting to maximize their own well-being. He observed that legislators' behavior is driven by their desire to stay in office, which requires that they maximize political support. Regulation is one way to redistribute wealth, and interest groups compete for that wealth by offering political support in exchange for favorable legislation.

This theory implies that regulation is likely to be biased toward benefiting interest groups that are well organized and that stand to gain from the wealth redistribution. Hence, regulation is likely to benefit small interest groups with strongly felt preferences at the expense of large interest groups with weakly felt preferences.

Because there often are competing interests in a particular issue, the economic theory of regulation suggests that regulation will reflect a balance of political forces rather than always serving the regulated industry, as the capture theory suggests. Indeed, if special interests coincide with the public interest, or if citizens are concerned enough about a particular issue for it to affect their voting behavior, regulation may serve the public interest.

PUBLIC CHOICE

PUBLIC CHOICE IS not a theory of regulation per se, but an economic analysis of government behavior that recognizes that (1) individuals in government (politicians, regulators, voters, etc.) are driven by self-interest, just as individuals in other circumstances are, and (2) they are not omniscient. Public choice analysis posits that government officials are not systematically engaged in maximizing the public interest, but are attempting to maximize their own private interests. It thus reaches conclusions similar to those drawn from Stigler's economic theory of regulation. In particular, public choice is concerned with the economic waste inherent in efforts to change laws or regulations in order to privilege one group over another. Such activity is called *rent-seeking*.[3]

For example, consider a domestic steel producer facing competition from cheaper foreign steel. Suppose there are two ways the domestic manufacturer could respond to the losses. First, it could innovate and invest in modernizing its plant to compete more successfully. Alternatively, it could pursue a rent-seeking strategy by making campaign contributions to politicians and hiring lobbyists to try to convince legislators to ban or restrict steel imports. The manufacturer may well choose the rent-seeking strategy if it is cheaper to implement than the modernization strategy. If the steel company—or, more likely, the trade association that represents the steel industry—is successful, society will be worse off for two reasons. First, the price of steel will increase, and since the gains to the steel producers will be less than the losses to consumers, there is economic waste. Second, resources that would otherwise be put to productive uses such as plant modernization or research and development are spent on lobbying, creating another net societal loss.

3. Gordon Tullock, *The Economics of Special Privilege and Rent Seeking* (Norwell, MA: Kluwer Academic Publishers, 1989), 55–56.

Public choice also recognizes that policymakers cannot always predict the consequences of different policy choices, so market interventions may produce "government failures." That is, even when a market failure is observed, a particular government intervention may produce even more inefficiency than the status quo as a result of the rent-seeking problem, unintended consequences, or both. For example, federal regulations on pharmaceuticals are intended to protect the public by ensuring that the drugs sold are not just safe but also effective for their particular uses. However, this intervention causes new drugs, ultimately shown to be safe and effective, to be introduced in the market years later than they otherwise would have been. As a result, many people die or suffer unnecessarily.

Two questions might arise about the conclusions of the economic and public choice models. First, why do politicians and interest groups resort to regulation to transfer wealth from the general public to private interests when direct cash transfers would be less costly to all concerned? Second, why do politicians often rely on public interest rhetoric when imposing regulations that transfer wealth to a small group? The public choice response is that special interests are disinclined to seek direct wealth transfers because their machinations would be too obvious. Instead, regulatory approaches that purport to provide public benefits confuse the public and reduce voter opposition to transfers of wealth to special interests.

BOOTLEGGERS AND BAPTISTS

BRUCE YANDLE COLORFULLY dubbed a special case of the economic theory of regulation the "bootleggers and Baptists" phenomenon. Yandle observed that unvarnished special interest groups cannot expect politicians to push through legislation that simply raises prices on a few products so that

the protected group can get rich at the expense of consumers. Like the bootleggers in the early-20th-century South, who benefited from laws that banned the sale of liquor on Sundays, special interests need to justify their efforts to obtain special favors with public interest stories. In the case of Sunday liquor sales, the Baptists, who supported the Sunday ban on moral grounds, provided that public interest support. While the Baptists vocally endorsed the ban on Sunday sales, the bootleggers worked behind the scenes and quietly rewarded the politicians with a portion of their Sunday liquor sale profits.

Modern-day stories of bootleggers and Baptists abound. Large biotechnology companies join with food safety activists to encourage stricter regulation of new foods involving genetic engineering, thus putting smaller competitors who cannot afford the regulatory compliance costs at a disadvantage. Tobacco companies supported legislation that would have required cigarettes to receive FDA premarketing approval, which would make it harder for new brands to enter the market. Solar power manufacturers support regulation that inhibits the production of conventional, competing sources of power (oil, coal, and gas). Food and toy companies lobby for more regulation to ensure their products' safety, thereby keeping out foreign competitors that may not be able to demonstrate that their products meet the same standards. U.S. testing laboratories argue on safety grounds against European requests to permit manufacturers of low-risk workplace electrical products to self-certify compliance with regulations rather than subject them to third-party testing. Big box retailers with vast resources are the largest supporters of minimum wage laws that raise the costs of doing business for their mom-and-pop competitors.

INSIGHTS FROM REGULATORY THEORY

THIS DISCUSSION IS not meant to suggest that people never behave altruistically, or that regulations are never motivated by public interest goals. Rather, the school of public choice and the economic theory of regulation have shed light on when we are likely to observe regulation and what forms it will tend to take. These theories have generally proven useful in explaining regulatory activity. They also tell us that, regardless of ideals and intentions, politicians have the same incentives as other people to maximize their own well-being. Thus, small, organized interest groups can sway the political will to gain specialized benefits while spreading the costs to all citizens. This phenomenon may explain why all modern presidents have endorsed nonpartisan principles for examining the likely effects of individual regulations before they are implemented. It may also explain why they all have deviated from these principles at one time or another.

FURTHER READING

Peter Aranson. "Theories of Economic Regulation: From Clarity to Confusion. *Journal of Law and Policy* 247, no. 6 (1990), 247-287.

J. Howard Beales III. *Business and Government Relations: An Economic Perspective*. Dubuque, IA: Kendall Hunt Publishing, 2009.

James Rolph Edwards. "The Economic Theory of Regulation." Chap. 5 in *Regulation, the Constitution, and the Economy: The Regulatory Road to Serfdom*. Lanham, MD: University Press of America, 1998.

Richard Epstein. "Why the Modern Administrative State Is Inconsistent with the Rule of Law." *NYU Journal of Liberty and Law* 491, no. 3 (2008), 491-514.

Robert W. Hahn. "Regulation: Past, Present, and Future." *Harvard Journal of Law and Public Policy* 167, no. 13 (1990), 167-228.

George Stigler. "The Theory of Economic Regulation." *Bell Journal of Economics* 2, no. 1 (1971): 3. http://wikisum.com/w/Stigler:_The _theory_of_economic_regulation.

Gordon Tullock. *The Economics of Special Privilege and Rent Seeking*. Boston: Springer, 1989.

Gordon Tullock, Arthur Seldon, and Gordon L. Brady. *Government Failure: A Primer in Public Choice*. Washington, DC: Cato Institute, 2002.

W. Kip Viscusi, John M. Vernon, and Joseph E. Harrington. *Economics of Regulation and Antitrust*. 3rd ed. Cambridge, MA: MIT Press, 2001.

Bruce Yandle. "Bootleggers and Baptists in Retrospect." *Regulation* 22, no. 3 (1999): 5–7. http://www.cato.org/pubs/regulation/regv22n3/bootleggers.pdf.

Bruce Yandle. "Bootleggers and Baptists: The Education of a Regulatory Economist." *Regulation* 7, no. 3 (May/June 1983): 12–16. http://www.cato.org/pubs/regulation/regv7n3/v7n3-3.pdf.

3

REGULATION AND THE CONSTITUTION: WHAT WOULD THE FOUNDERS SAY?

AMERICA'S FOUNDING FATHERS did not design our Constitution so that the legislature would be efficient at passing laws. Rather, based on their experience, the framers felt it important to design a government that would not allow the majority to rule with an iron fist. To avoid giving government officials too much power, they based our government on the notion known as the *separation of powers*, wherein power is divided among three branches of government: the legislative branch, the executive branch, and the judicial branch. The Constitution also includes *checks and balances* through which one branch can challenge the powers or decisions of another branch.

As the Supreme Court has explained, the Constitution "divides power among sovereigns and among branches of government precisely so that we may resist the temptation to concentrate power in one location as an expedient solution to the crisis of the day."[4] James Buchanan and Gordon Tullock

4. New York v. United States, 505 U.S. 144, 187 (1992).

demonstrated in *The Calculus of Consent* that requiring consent from multiple branches of government chosen in diverse ways leads to decisions that are more likely to reflect a society-wide consensus while avoiding some of the obvious costs of requiring that government decisions have the unanimous consent of everyone in society.

The Constitution grants the *legislative branch* the power to pass laws. It tasks the *executive branch* with the administration and enforcement of those laws and makes the *judicial branch* responsible for settling conflicts arising from those laws. This chapter examines how these three branches' roles have evolved over time with respect to regulation.

LEGISLATIVE BRANCH – ARTICLE I

ARTICLE I OF the Constitution establishes the Senate and House of Representatives and vests all legislative powers in these bodies. Section 8 of Article I lists the powers of Congress, which include the following:

> To lay and collect Taxes, Duties, Imposts and Excises, to pay the Debts and provide for the common Defence and general Welfare of the United States; but all Duties, Imposts and Excises shall be uniform throughout the United States;

> To regulate Commerce with foreign Nations, and among the several States, and with the Indian Tribes; To establish an uniform Rule of Naturalization, and uniform Laws on the subject of Bankruptcies throughout the United States;

To make all Laws which shall be necessary and proper for carrying into Execution the foregoing Powers, and all other Powers vested by this Constitution in the Government of the United States, or in any Department or Officer thereof.

EXECUTIVE BRANCH – ARTICLE II

ARTICLE II VESTS all *executive* power in the president. Section 3 of Article II specifies that the president "shall take Care that the Laws be faithfully executed."

JUDICIAL BRANCH – ARTICLE III

ARTICLE III STATES that the "judicial Power of the United States shall be vested in one supreme Court, and in such inferior Courts as the Congress may from time to time ordain and establish."

THE BILL OF RIGHTS

THE FIRST TEN amendments to the Constitution further clarify the roles of the different branches and protect the freedoms of religion, speech, the press, security in people's homes, weapons ownership, and the process of law. Of particular note with respect to federal regulation is the Tenth Amendment, which states, "The powers not delegated to the United States by the Constitution, nor prohibited by it to the States, are reserved to the States respectively, or to the people."

EXECUTION VS. LAWMAKING

WHAT IS "EXECUTIVE power" as it is used in Article II of the Constitution? It means to carry into effect (execute) the laws of

the nation, laws that are written by Congress. Thus, it is the power to administer and enforce laws, but not to make or enact them.

In some statutes, Congress states goals that an agency is mandated to meet. For example, the Clean Water Act mandates reductions in well-defined waterborne contaminants. In other statutes, Congress grants broad powers to an agency to determine within a certain field what is to be regulated and how to accomplish it. For example, the Occupational Safety and Health Act directs OSHA to issue "occupational safety and health standards." A brief review of the history of jurisprudence reveals how such broad delegation of powers, once thought to be legislative in nature, came to pass.

A BRIEF HISTORY OF THE NONDELEGATION DOCTRINE

UNTIL THE EARLY part of the 20th century, courts interpreted the separation of powers implicit in Articles I through III of the Constitution as prohibiting the delegation of legislative powers to the executive. This is known as the nondelegation doctrine. It states, "That Congress cannot delegate legislative power to the President is a principle universally recognized as vital to the integrity and maintenance of the system of government ordained by the Constitution."[5]

Over the last century, however, this separation of powers has blurred, and Congress now frequently grants executive branch agencies the authority to write as well as administer and enforce regulations, which are sometimes referred to as *administrative laws*. As statutes have increasingly delegated legislative power to executive agencies, courts have struggled with the constitutionality of executive branch rulemaking.

In 1928, the Supreme Court moved away from a strict interpretation of the nondelegation doctrine by introducing the

5. Field v. Clark, 143 U.S. 649 (1892).

notion of an "intelligible principle." In *J. W. Hampton, Jr. &
Company v. United States*, it found that a congressional delega-
tion of power was constitutional because the statute included
an intelligible principle to guide executive action.[6] That is, as
long as Congress provides executive agencies with an unam-
biguous standard to guide rulemaking, it may delegate its law-
making authority. However, an "intelligible principle" may be
as broad as a mandate to regulate "in the public interest."

In 1935, the Supreme Court returned to the question of
the constitutionality of congressional delegation, but this
time, in *Schechter Poultry Corp. v. United States*, it ruled that
the National Industrial Recovery Act was unconstitutional
because it provided the president (and private industry asso-
ciations) with "virtually unfettered" decision-making power.[7]

While the nondelegation doctrine has been mentioned occa-
sionally in individual justices' opinions over the last 70 years,
the *Schechter* decision in 1935 was the last time the Supreme
Court found a statute unconstitutional on nondelegation
grounds.

In 1946, Congress attempted to delineate the procedures by
which executive agencies could write administrative law. The
Administrative Procedure Act (APA) established procedures
for executive rulemaking and continues to guide rulemaking
today. It is described below.

THE NONDELEGATION DOCTRINE TODAY

SOME CONSTITUTIONAL SCHOLARS argue that granting
unelected executive branch agencies the power to write,
administer, and even enforce regulations is contrary to the
Constitution and distinctly a second-best option to legislation

6. J. W. Hampton, Jr. & Co. v. United States, 276 U.S. 394 (1928).

7. A. L. A. Schecher Poultry Corp. v. United States, 295 U.S. 495 (1935).

by the people's elected representatives in Congress. Other scholars respond that experts in the executive branch are better able to make decisions on technical issues or to resolve controversial issues in a less political manner. In 1989, the Supreme Court came down clearly on the side of delegation, stating, "In our increasingly complex society, replete with ever changing and more technical problems, Congress simply cannot do its job absent an ability to delegate power under broad general directives."[8]

The nondelegation doctrine was revived temporarily by a 1999 District of Columbia circuit court decision in *American Trucking Associations, Inc., v. EPA*. The court ruled that because the EPA had failed to articulate an intelligible principle constraining its regulation setting ambient air quality standards, its interpretation of the Clean Air Act was equivalent to an unconstitutional delegation of legislative authority. In 2001, however, the Supreme Court overturned the circuit court's decision, opining that the constitutional question was whether the *statute* improperly delegated legislative power to the agency and that an *agency's interpretation* of a statute could not determine whether the underlying statute was constitutional.[9]

The accepted role of the executive branch in issuing regulation has thus evolved to include a broad measure of discretion and interpretive freedom. Congress must set forth basic policy and it cannot delegate rulemaking authority to the executive without specifying an intelligible principle for agencies to follow. In practice, however, this standard has not proven to be constraining. Indeed, the Supreme Court observed in 2001 that courts have "almost never felt qualified to second-guess

8. Mistretta v. United States, 488 U.S. 361 (1989).

9. Whitman v. Am. Trucking Ass'n, 531 U.S. 472 (2001).

Congress regarding the permissible degree of policy judgment that can be left to those executing or applying the law."[10]

INDEPENDENT REGULATORY AGENCIES

IN ADDITION TO executive branch agencies, some regulations are carried out by independent regulatory agencies or commissions (often abbreviated IRCs). IRCs, such as the Federal Communications Commission and the Commodity Futures Trading Commission, do not fall clearly into the realm of any of the three branches of government. Members of these commissions must reflect a balance of political parties, are appointed to specific terms by the president, and are confirmed by Congress. As we will see in the next chapter, IRCs are not subject to regulatory review by the executive.

ADMINISTRATIVE PROCEDURE ACT OF 1946

THE APA ESTABLISHED procedures an agency must follow to promulgate binding rules and regulations within the area delegated to it by statute. As long as an agency acts within the rulemaking authority delegated to it by Congress and follows the procedures in the APA, courts have ruled that an agency is entitled to write and enforce regulations (subject to judicial checks).

The APA constrains executive rulemaking in three main ways:

1. The agency can only act within the limits set by statute.

2. The agency actions must meet the following tests:

 a. be reasonable (i.e., have sufficient factual support in the record)

10. Ibid., 474–75.

b. not be arbitrary or capricious

c. not be an abuse of discretion

3. The agency must follow specified procedures. In particular, it must notify the public of the proposed action and consider public comments before issuing a final rule.

The next chapter provides more detail on the procedures specified by the APA.

FEDERALISM AND THE COMMERCE CLAUSE

THE FOUNDERS DRAFTED the Constitution to limit the power of the national government through the separation of powers, checks and balances, and the amendments. The Tenth Amendment states that powers not specifically delegated by the Constitution to the national government "are reserved to the States respectively, or to the people." The appeal of this concept, known as *federalism*, is that it encourages diversity in laws among states seeking to serve the different needs of citizens and firms. It also forces states to compete for residents (taxpayers, entrepreneurs, etc.). Moreover, as James Madison explained in *The Federalist*, federalism provides a "double security" from usurpations of individual liberties by federal and state governments.[11]

If the federal government only has power over national matters and local matters are left to the states, how is it that the FCC regulates radio stations transmitting inside a single state? How is it that EPA rules govern a city's water system? The answer is that while states are better suited to serve citizens'

11. James Madison, "The Federalist No. 51," *Independent Journal*, 1788, http://www.constitution.org/fed/federa51.htm.

needs and experiment with different approaches to governing (through taxes, laws and regulations, etc.), the Constitution does reserve for the legislative branch of the federal government the power to regulate commerce among the states. This power is supposed to prevent the significant burdens on interstate commerce that might occur if individual states taxed or prohibited products from other states.

In the 1942 case of *Wickard v. Filburn*, the Supreme Court found that even the most local of activities may have an effect on interstate commerce and be subject to federal regulation.[12] The case involved Roscoe Filburn, a farmer who grew wheat on his property in Ohio for his family's own on-farm consumption. At the time, the federal government limited how much wheat individual farmers could grow as a way to boost wheat prices during the Great Depression. Filburn was fined and ordered to destroy his crops. He then challenged the constitutionality of the federal wheat quotas. The Court ruled that because Filburn was growing wheat for himself, it meant he was buying less on the open market than he would otherwise, and because the wheat market is national, his activity was affecting interstate commerce.

Since then, it has become widely accepted that there are few local activities that do not have a nexus with interstate commerce allowing the federal government to regulate. In 1990, the Supreme Court embarked on a limited revival of federalism in *U.S. v. Lopez*.[13] In that case the Court found that possession of a firearm near a school, which was prohibited by federal law, did not constitute an economic activity having an effect on interstate commerce. By rejecting the argument that gun possession has a nexus to interstate commerce, the case signaled that the Supreme Court still

12. Wickard v. Filburn, 317 U.S. 111 (1942).

13. U.S. v. Lopez, 514 U.S. 549 (1995).

believed that there are limits to congressional power under the Commerce Clause.

Most recently, the Supreme Court found the Patient Protection and Affordable Care Act (PPACA) unconstitutional under the Commerce Clause.[14] Although the Court ultimately upheld the Act under the Constitution's Taxing Clause, the majority's opinion continued to identify the limits of congressional power under the Commerce Clause. It found that Congress's power to regulate activities that have a nexus with interstate commerce cannot be used to require individuals to purchase health insurance. Failure to purchase insurance may affect interstate commerce, the Court reasoned, but it is not an economic activity that can be regulated. "Construing the Commerce Clause to permit Congress to regulate individuals precisely because they are doing nothing would open a new and potentially vast domain to congressional authority," the Court explained.

APPLYING FEDERALISM

WHEN ANALYZING A proposed rule, it is important to understand the constitutional limits to federal regulation. Yet even when it is clear that the federal government has the power to regulate, there are many reasons why it may be best to forbear and allow a more local level of government to develop its own policies.

Localities will tend to have better information about how a problem affects citizens, allowing them to tailor better solutions. Also, different competing approaches to a problem will drive innovation. As Louis Brandeis said, "It is one of the happy incidents of the federal system that a single courageous

14. National Federation of Independent Business v Sebelius 393 S. Ct. 567 (2012).

state may, if its citizens choose, serve as a laboratory; and try novel social and economic experiments without risk to the rest of the country." Finally, local governments are more responsive to their constituencies and, therefore, more accountable for their decisions.

In addition to examining costs and benefits when considering regulatory alternatives, it is also important to consider which level of government is best suited to address a problem. Not only does the federal government sometimes lack the power to regulate, it is often not positioned to produce the best outcome.

FURTHER READING

James M. Buchanan and Gordon Tullock. *The Calculus of Consent.* University Park, IL: Liberty Fund, 2004.

U.S. House of Representatives. "The Legislative Process." http://www.house.gov/content/learn/legislative_process/.

James Madison. "The Federalist No. 51." *Independent Journal,* 1788. http://www.constitution.org/fed/federa51.htm.

Morton Rosenberg and Jack H. Maskell. *Congressional Intervention in the Administrative Process: Legal and Ethical Considerations.* Washington, DC: Congressional Research Service, 2003. http://assets.opencrs.com/rpts/RL32113_20030925.pdf.

David Schoenbrod. *Power Without Responsibility: How Congress Abuses the People through Delegation.* New Haven, CT: Yale University Press, 1993.

John W. Sullivan. *How Our Laws Are Made.* Washington, DC: GPO, 2007. http://www.gpo.gov/fdsys/pkg/CDOC-110hdoc49/pdf/CDOC-110hdoc49.pdf.

4

THE REGULATORY PROCESS: HOW IS THE SAUSAGE MADE?

I have come to the conclusion that the making of laws is like the making of sausages—the less you know about the process the more you respect the result.

—Anonymous[15]

THIS CHAPTER EXPLORES how regulations are made. After briefly reviewing the procedures for developing regulations under the APA, we examine the roles the public, executive branch agencies, and Congress play in developing regulations.

As discussed in the previous chapter, Congress must grant an agency legal authority to issue regulations. To become law, a statute must pass both houses of Congress and be signed by the president. Some statutes, like the Hazardous and Solid Waste Amendments, prescribe in detail how regulatory standards should be designed. Others provide executive agencies with

15. This oft-quoted (and sometimes misquoted) remark was made by an unknown member of Congress in the 1870s. Frank W. Tracy, "The Report of the Committee on Uniform Laws, of the American Bankers' Association," *Banking Law Journal* 542, no. 15 (1898).

more general guidance; for example, section 109 of the Clean Air Act directs the EPA to set standards that "protect the public health . . . [with] an adequate margin of safety."[16]

When writing regulations, agencies are constrained by the APA and by enabling legislation.

APA PROCEDURES

THE APA, INTRODUCED in the previous chapter, describes two types of rulemaking—formal and informal.

Formal Rulemaking

FORMAL RULEMAKING HAS mainly been used by agencies responsible for economic regulation of industries and is only required when a statute other than the APA specifically states that rulemaking is to be done "on the record."[17] Formal rulemaking involves hearings and the presentation of formal documentation to support the rule in front of a commission or administrative law judge, and parties may "conduct such cross-examination as may be required for a full and true disclosure of the facts."[18] In subsequent judicial review, the agency proposing the rule has the burden of proof, and the rule must be based "on consideration of the whole record . . . and supported by . . . substantial evidence."[19] Generally speaking, formal regulation is rare except in cases of "ratemaking" by a regulatory commission (such as when the Federal Energy Regulatory Commission determines acceptable rates that electric transmission companies may charge for transporting power).

16. Clean Air Act, sec. 109.

17. *U.S. Code* 5, § 556.

18. *U.S. Code* 5, § 556(d).

19. Ibid.

Informal Rulemaking

INFORMAL RULEMAKING, OR notice and comment rulemaking, is the most common process used by agencies for writing, or "promulgating," regulations.[20] The agency or department first proposes a rule or standard and invites public comment through a Notice of Proposed Rulemaking (NPRM, sometimes also abbreviated as NOPR). Though not required by the APA, in some cases the agency will issue an Advance Notice of Proposed Rulemaking to gather information from the public before issuing a prospective rule. After reviewing public comments on a proposed rule, the agency may issue a final rule.

Occasionally, agencies will engage in *negotiated rulemaking* to bring different stakeholders to the table jointly to draft a proposed regulation. The resulting draft must still comply with the APA's informal rulemaking requirements and go through public notice and comment, and the final rule must be based on the rulemaking record.

Hybrid Rulemaking

SOME STATUTES (NOTABLY the Occupational Safety and Health Act, the Toxic Substances Control Act, and sections of the Clean Air Act) call for opportunities for public involvement that are a combination of those required by the formal and informal rulemaking procedures laid out in the APA. Under hybrid rulemaking, agencies generally publish an NPRM for public comment and also provide opportunities for public hearings on the record. As a result, hybrid rulemakings maintain some of the flexibility of informal rulemakings while providing greater opportunities for public engagement.

20. *U.S. Code* 5, § 553.

EXEMPTIONS TO APA PROCEDURES

THE APA PROVIDES "good cause" exemptions to the informal rulemaking notice-and-comment requirements if the regulatory agency can show that traditional procedures are "impracticable, unnecessary, or contrary to the public interest." Agencies sometimes issue Interim Final Rules (IFRs) relying on the "good cause" justification. For instance, in the aftermath of a disaster such as a hurricane or terrorist attack, agencies may issue emergency regulatory waivers via IFRs. IFRs can become effective without going through public notice and comment. Agencies are expected to consider public comment after issuing the IFR, however, and eventually issue a permanent final regulation.

Agencies will also sometimes use Direct Final Rules (DFRs) to issue regulations considered "routine or noncontroversial," relying on the "unnecessary" component of the "good cause" exception. For example, the EPA routinely issues DFRs to approve revisions to state implementation plans under the Clean Air Act, and these generate little or no public comment. DFRs become effective on a certain date unless the agency receives adverse public comment. If it does, it must withdraw the rule, but it may commence regular informal notice-and-comment rulemaking to promulgate the regulation.

The APA also exempts from all procedural requirements rules pertaining to (1) "a military or foreign affairs function of the United States," (2) "a matter relating to agency management or personnel," or (3) a matter relating to "public property, loans, grants, benefits, or contracts."

"Nonlegislative" Rules

THE APA EXEMPTS from its notice and comment procedures "interpretive rules" and "policy statements." While these

"nonlegislative" rules and "guidance documents" do not carry the force of law and are not legally binding, they are often binding in practical effect. Standards may be set through policies, guidelines, executive orders, and enforcement cases. For example, businesses are guided by the kinds of cases that an agency brings. Similarly to the way that existing case law functions in the legal realm, enforcement cases help define what the Federal Trade Commission, for example, may view as deceptive advertising. Standards might be applied as fixed criteria in enforcement or approval proceedings. Agencies might also guarantee approval for practices or freedom from enforcement action under "safe harbor" provisions as long as certain guidance is followed.

In an effort to increase the quality and transparency of nonlegislative rules, recent executive directives have established policies and procedures for the development, issuance, and use of significant guidance documents by executive branch departments and agencies.

PUBLIC INVOLVEMENT

WHILE INTERESTED PARTIES (e.g., lobbying organizations and those affected by the rule) are often aware of an agency's regulatory plans and communicate with the agency during the development of a proposed rule, the informal rulemaking process articulated in the APA requires agencies to provide broad public notice of their intended actions by publishing a proposed rule (i.e., an NPRM) in the *Federal Register*. The *Federal Register* notice specifies a period for public comment that can range from 30 to 120 days or more depending on the complexity of, and interest in, the proposal. The public is invited to submit comments on the rule during this period, and agencies collect these comments in the rulemaking record.

After the comment period closes, the agency reviews the comments and decides whether to publish a final rule. According to the APA, the final rule must be based on this rulemaking record. Otherwise, the agency could be sued by an affected party and the regulation overturned for being "arbitrary and capricious."

In addition to providing notice in the *Federal Register*, agencies now post regulations open for comment on their individual websites and on the government-wide portal, http://www.regulations.gov. Visitors can view and comment electronically on regulations proposed by different agencies. The promise of "e-rulemaking" has been greater citizen participation and collaboration in the rulemaking process.

Not only does the Internet dramatically reduce the cost of citizens' access to regulatory information and the cost of submitting comments, but it could also make possible collaborative experiences not previously feasible. For example, social media could be used to spread the word on an agency proposal and facilitate a discussion about it, and wiki technology could allow dozens, if not hundreds, of individuals to collaborate on regulatory filings. E-rulemaking's full potential has yet to be realized, however.

EXECUTIVE OFFICE REVIEW

OVER THE LAST 30 years, Congress and presidents have added steps to the procedures for issuing and reviewing regulation. This section looks at the role of executive branch agencies other than the issuing agency in developing and reviewing new regulations.

Office of Management and Budget

THE PRESIDENT, as chief executive, is responsible for executive branch agency actions. Every president since Nixon has

established procedures for executive review of agency regulation.

Executive Order 12866 (E.O. 12866), issued by President Clinton in 1993, continues to guide the development and review of regulations today. E.O. 12866, like its predecessor, E.O. 12291, expresses the philosophy that regulations should (1) address a "compelling public need, such as material failures of private markets"; (2) be based on an assessment of "all costs and benefits of available regulatory alternatives, including the alternative of not regulating"; and (3) "maximize net benefits" to society unless otherwise constrained by law.

E.O. 12866 requires, among other things, that a regulatory analysis be performed on all rules deemed to be of significant economic impact (i.e., that have an effect of $100 million or more in a year).[21] The regulatory analysis must include a statement of need for the regulation, an assessment of alternative regulatory approaches, and a benefit–cost analysis.

E.O. 12866 also requires that agencies submit significant regulations for review by OIRA before publication in the *Federal Register* in proposed or final form (see figure 4, page 54). OIRA policy analysts evaluate draft regulations and their accompanying analysis against the requirements of presidential executive orders and coordinate interagency review when appropriate. Other officials within the executive branch, including those representing White House policy councils and other agencies with an interest in the regulation, are invited to

21. E.O. 12866 defines a "significant regulation" as one that may "create a serious inconsistency or otherwise interfere with an action taken or planned by another agency; materially alter the budgetary impact of entitlements, grants, user fees, or loan programs or the rights and obligations of recipients thereof; raise novel legal or policy issues" or "have an annual effect on the economy of $100 million or more or adversely affect in a material way the economy, a sector of the economy, productivity, competition, jobs, the environment, public health or safety, or State, local, or tribal governments or communities." The subset of significant regulations that are expected to "have an annual effect on the economy of $100 million or more" are classified as "economically significant." Executive Order no. 12,866, *Federal Register* 58, no. 190 (September 30, 1993), http://www.plainlanguage.gov/populartopics/regulations/eo12866.pdf.

participate in this interagency review, which can last 90 days or longer if extended. (The average review time is under 60 days.)

OIRA posts on its website a list of rules under review at any given time. Members of the public may request a meeting with OIRA while a regulation is under review. These meetings serve as listening sessions, where OIRA staff, issuing agency representatives, and interested White House staff hear from parties interested in the rule. OIRA posts on its website all meeting participants and any materials presented by outside parties.

OIRA usually concludes a review by declaring that the draft regulation is (1) consistent with E.O. 12866 as originally drafted, or (2) consistent as changed during the review process. Sometimes, review is concluded when (3) an agency withdraws the regulation or (4) OIRA returns the regulation for the agency's consideration with a letter identifying the elements of E.O. 12866 with which the draft was not consistent. Finally, judicial or statutory deadlines may truncate interagency review, in which case OIRA concludes review to meet the deadline without opining on whether it is consistent with the executive order. Once OIRA has completed its review of a rule, the agency may publish it in the *Federal Register*, either for public comment, in the case of proposed rules, or as a final regulation with the force of law.

OIRA is also responsible for reviewing and approving agencies' requests for information from the public. Under the Paperwork Reduction Act (see below), agencies must obtain an OMB control number before collecting information from 10 or more members of the public. Members of the public may refuse to respond to any request for information that does not have an OMB control number.

The Small Business Administration's Office of Advocacy

THE OFFICE OF Advocacy in the Small Business Administration (SBA) has emerged in recent years as a significant player in the regulatory development and oversight process. In 1976, Congress created the office to provide an independent voice within the federal government for small businesses. The passage of the Regulatory Flexibility Act of 1980 (RFA) gave the office more clout.[22] The RFA requires agencies to consider the effects of their regulatory actions on small businesses and other small entities[23] and to consider less burdensome alternatives. It puts the Office of Advocacy in charge of monitoring agency compliance with the act and submitting annual reports to Congress.

The Small Business Regulatory Enforcement Fairness Act (SBREFA), passed by Congress in 1996, reflected concerns that agencies were not always following the RFA and that the lack of an enforcement mechanism left small businesses little recourse in the courts. SBREFA amended the RFA by specifying the steps an agency must take to minimize a regulation's economic impact on small businesses and by permitting judicial review of agencies' compliance. In 2003, the SBA published the *Guide for Government Agencies on How to Comply with the Regulatory Flexibility Act*.

SBREFA also required that two agencies—the EPA and OSHA—receive input from affected small businesses through the SBA's Office of Advocacy before publishing a proposed rule. The Dodd–Frank Wall Street Reform and Consumer Protection Act of 2010 added the new CFPB to the agencies subject to these Small Business Advocacy Reviews (SBARs).

When a new proposal is expected to have a "significant

22. *U.S. Code* 5, § 601–12.

23. Small entities include small non-business groups such as non-profits and government jurisdictions.

economic impact on a substantial number of small entities,"[24] SBREFA requires the EPA, OSHA, and the CFPB to convene an SBAR panel. The panel consists of representatives from the agency, the Office of Advocacy, and OIRA who review the draft proposed rule and related agency analyses under the RFA. The panel also solicits advice from small business representatives and prepares a report to the regulating agency, which must consider the report in developing the proposal and include it in the public record of the rulemaking.

Other Agencies

WHEN FEDERAL AGENCIES' regulatory jurisdictions or authorities overlap or when one rulemaking affects another agency's areas of interest and expertise, the agencies often share information and resolve disagreements during the OIRA review process. For example, the USDA may provide information on the effects of a proposal on agricultural markets, or the Department of Energy might raise issues related to the energy impacts of another agency's proposal. For some types of regulation, legislation requires the issuing agency to consult with another agency. For example, the DOE must submit all energy efficiency regulations to the Department of Justice's Antitrust Division for an assessment of how the regulations will affect competition.

CONGRESS'S ROLE

EXECUTIVE AGENCIES EXERT their regulatory authority under delegation from Congress. Congress monitors agencies' activities through oversight committees, each of which is designated to a specific agency. Through oversight hearings, oversight committee members can hear the testimony of agency

24. *U.S. Code* 5, § 605(b).

representatives concerning the regulatory actions of their respective agencies. If Congress is displeased with an agency's implementation of its mandates, it can attempt to guide the process through regulatory oversight, or it can pass another law with new directives. Through its appropriations committees, Congress can also reduce the agency's budget or forbid agencies to use money in certain ways.

These mechanisms can be cumbersome and time consuming, however. To gain more control over the regulatory process, Congress has passed a number of legal requirements in recent years governing factors the executive branch must evaluate, information it must provide, and procedures for third-party review of regulations.

The following are some of the most important regulatory review laws:

- the Regulatory Flexibility Act of 1980, which requires agencies to assess the impact of a regulation on small businesses and provides for review by the SBA

- the Paperwork Reduction Act (PRA) of 1980 (amended in 1995), which established OIRA within the OMB to review the paperwork and information-collection burdens imposed by the federal government

- the Unfunded Mandates Reform Act (UMRA) of 1995, which requires regulatory agencies to consider burdens on state, local, and tribal governments

- the Small Business Regulatory Enforcement Fairness Act of 1996, which enforces requirements for small business impact analyses under the RFA

- the Congressional Review Act (CRA) of 1996, contained in SBREFA, which requires rule-issuing agencies to send all mandated documentation that is submitted to the OMB to both houses of Congress as well. It also allows Congress to overturn regulations within a specified time with a congressional resolution of disapproval[25]

- the Omnibus Consolidated and Emergency Supplemental Appropriations Act of 1999 (section 638(a)), which requires the OMB to report to Congress yearly on the costs and benefits of regulations and to provide recommendations for reform

- the Truth in Regulating Act of 2000, which gives Congress the authority to request that the U.S. Government Accountability Office (GAO) conduct an independent evaluation of economically significant rules at the proposed or final stages

- the Information Quality Act of 2000, which required the OMB to develop government-wide standards for ensuring and maximizing the quality of information disseminated by federal agencies. Under the guidelines, agencies must follow procedures for ensuring the utility, integrity, and objectivity of information used in rulemaking and elsewhere. They also must offer an

25. While several resolutions of disapproval have passed one chamber of Congress, only one joint resolution of disapproval has passed both. It overturned an OSHA regulation addressing ergonomics in the workplace. Though resolutions of disapproval require only a simple majority in Congress, they face the threat of presidential veto, which would require a two-thirds majority to override. The conditions surrounding the ergonomics regulation were likely key to its disapproval. It was a "midnight regulation" issued amid much controversy at the end of the Clinton administration. The resolution disapproving the rule came at the beginning of the Bush administration (which did not support the rule), eliminating the veto threat.

administrative mechanism for responding to public requests to correct poor-quality information that has been or is being disseminated.

A NOTE ABOUT INDEPENDENT REGULATORY COMMISSIONS

WHILE NOMINALLY PART of the executive branch, IRCs operate more independently than executive agencies. They are typically composed of five or more members ("commissioners") who are appointed for fixed terms by the president and confirmed by the Senate. Presidents exercise less control over IRCs than they do over executive-branch agencies, in part because unlike executive agency appointees, who serve "at the pleasure of the president" and can be fired for any reason, IRC commissioners can only be dismissed "for good cause."

Whether IRCs can be made subject to an executive order mandating regulatory review remains a controversial question. It is clear that the president could fire and replace an *executive department* head who refused to abide by an executive order. However, whether ignoring an executive order mandating regulatory review would be sufficient "good cause" to dismiss an independent commissioner is unclear, especially since Congress created IRCs precisely so that the executive would not control them. As a result, no president has pressed the matter and IRCs are exempt from review under Executive Order 12866. President Obama's Executive Order 13579, however, did encourage IRCs to conduct retrospective review of the effectiveness of existing regulations.[26]

Some statutory requirements for regulatory procedure and analysis do apply to IRCs, however. These include the APA,

26. Executive Order no. 13,579, *Federal Register* 76, no. 14 (January 21, 2011), http://www.gpo.gov/fdsys/pkg/FR-2011-01-21/pdf/2011-1385.pdf.

PRA, RFA, UMRA, and CRA. Under the PRA, IRCs must submit information collection requests to OIRA for approval, but can override disapprovals through a vote of the commission. Additionally, the organic statutes of some IRCs include agency-specific statutory requirements for regulatory analysis. For example, the SEC, an independent commission that is not subject to E.O. 12866, is charged by its enabling statute to consider whether a proposed regulation "will promote efficiency, competition, and capital formation." This mandate has been interpreted as a requirement to conduct benefit-cost analyses. Nevertheless, IRCs generally provide less rigorous analysis of the likely impact of their regulations than do agencies subject to presidential oversight.

THE JUDICIARY'S ROLE

AFTER A REGULATORY agency promulgates a final rule, an affected party may challenge it in court. Following judicial review, the court may reverse the rule or remand it to the agency for reconsideration.

There are several grounds on which a rule may be reversed. The first is constitutional.[27] If a court finds an agency action to violate some constitutional protection, it will reverse the rule just as it would strike down an unconstitutional statute. The second ground for reversal is procedural.[28] If an agency does not comply with the APA's rulemaking procedures—for example, by providing less time for public comment than the APA requires—a court could reverse the rule.

The next set of grounds for reversal deals with agency determinations. When an agency develops a rule, it interprets the law that delegates its authority to act, it finds facts about the

27. *U.S. Code* 5, § 706(2)(B).

28. *U.S. Code* 5, § 706(2)(D).

matter at hand, and it employs its discretion in applying its legal interpretation to the facts. As a result, a rule may be reversed if the agency made improper determinations of law or fact or if it abused its discretion.[29] In reviewing a rule, a court will first look at whether an agency exceeded the statutory authority granted to it by Congress. If not, it will then look with more deference at the agency's factual determinations and exercise of discretion.

In the case of formal rulemaking, the APA requires a trial-type hearing at which a "party is entitled to present his case or defense or oral or documentary evidence, to submit rebuttal evidence, and to conduct such cross-examination as may be required for a full and true disclosure of the facts."[30] Judicial review of formal rulemaking requires courts to overturn a rule that is "unsupported by substantial evidence" on the record.[31] Formal rulemaking, however, is very rare. The more common way agencies promulgate regulations is through informal rulemaking. In assessing an informal rulemaking, a court will look with more deference at the agency's factual determinations and exercise of discretion to judge whether they are "arbitrary, capricious, an abuse of discretion, or otherwise not in accordance with law."[32]

A court looking at a rule promulgated through the informal rulemaking process will first look at whether the agency has the authority to do what it did. The court determines whether "Congress addressed the precise question at issue," and if so, it will "give effect to the unambiguously expressed intent of Congress."[33] If the statute clearly prohibits the agency

29. *U.S. Code* 5, § 706(2)(C); *U.S. Code* 5, § 706(2)(E); *U.S. Code* 5, § 706(2)(A).

30. *U.S. Code* 5, § 553(d).

31. *U.S. Code* 5, § 706(2)(E).

32. *U.S. Code* 5, § 706(2)(A).

33. Chevron U.S.A., Inc., v. NRDC, 467 U.S. 837 (1984).

from taking the action it did, then the rule will be reversed. However, if the statute is "silent or ambiguous with respect to the specific issue," then the court must decide whether the agency's interpretation of the statute is reasonable. In doing so, the court will defer to the agency's interpretation under the assumption that if Congress left the statute ambiguous, then it meant for the agency to fill the gap in a reasonable manner.

Next, a court will look at whether the agency's determinations pertain to the facts. It will look at whether the record shows that the agency has taken a "hard look" at the important factual issues and at whether there is a rational connection between the facts and the agency's decision. In an informal rulemaking, the record is composed of the notice of proposed rulemaking, comments from the public, the final rule, and any technical support documents prepared by agency staff. A regulation will survive challenge if the record contains evidence that would allow a reasonable person to accept the factual premises of the final rule.

Finally, a court will look at whether an agency exercised its discretion in an "arbitrary and capricious" manner. In this inquiry a court will look for a plausible analysis based on the record that would allow the agency to reach the conclusions it did. If none exists, the rule will be reversed.

SUMMARY OF THE REGULATORY DEVELOPMENT PROCESS

FIGURE 4 ILLUSTRATES the development process for significant regulations issued by executive branch agencies under the informal rulemaking procedures.[34] Constitutionally, all regulations must be authorized by Congress through legislative

34. As noted, IRCs are not subject to interagency review requirements, nor are regulations that agencies and OIRA do not designate as "significant."

statute, but a particular regulation may be triggered by different actions. A statute may direct an agency to conduct rulemaking by assigning deadlines for regulatory actions or updates. Alternatively, the executive branch may identify the need for a regulation that is consistent with the broad authority delegated to it by statute. Sometimes, nongovernmental parties will petition for a new regulation or sue an agency to regulate pursuant to its statutory authority.

Agencies announce the initiation of a rulemaking through the semiannual *Unified Agenda of Federal Regulatory and Deregulatory Actions,* an online list of all forthcoming and ongoing regulatory actions that is coordinated by OIRA. Both executive branch agencies and IRCs list their regulations in the agenda. Agencies often spend years developing a regulation before beginning to draft a proposal. They prepare supporting analysis as required by statute and executive order, and the EPA, OSHA, and the CFPB engage SBAR panels for regulations they expect to affect a significant number of small entities. Agencies send drafts of significant executive agency regulations to OIRA for review under E.O. 12866. After a draft regulation has passed these reviews, the originating agency publishes it in the *Federal Register* and the public has an opportunity to comment on it.

After reviewing public comments, the agency develops a final regulation and accompanying analysis, which executive agencies submit to OIRA for interagency review. Once OIRA concludes its review, agencies publish the final rule in the *Federal Register*. Under the CRA, agencies must also submit all final regulations to the GAO and to Congress. After final publication, regulations typically do not take effect for at least 30 days (60 days for major rules). Congress may issue a joint resolution of disapproval after a final regulation has been published, and regulations are also subject to judicial review.

FIGURE 4: PROPOSED RULE DEVELOPMENT

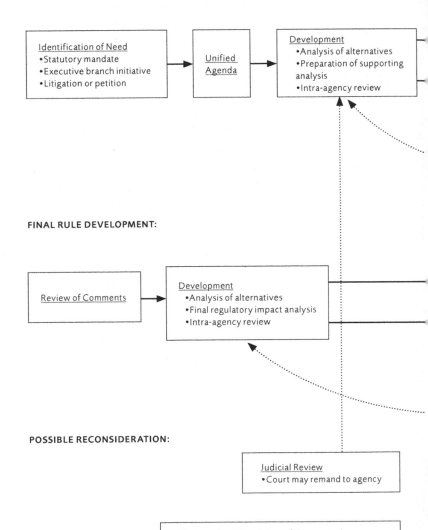

FINAL RULE DEVELOPMENT:

POSSIBLE RECONSIDERATION:

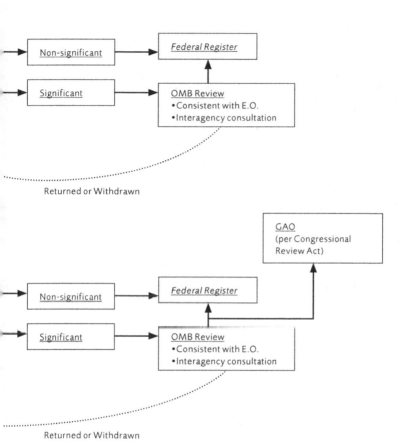

Source: Author's illustration based on Executive Orders.

FURTHER READING

Donald R. Arbuckle. "The Role of Analysis on the 17 Most Political Acres on the Face of the Earth." *Risk Analysis* 31, no. 6 (2011): 884–92.

Curtis W. Copeland. *The Federal Rulemaking Process: An Overview.* Washington, DC: Congressional Research Service. February 22, 2011. http://assets.opencrs.com/rpts/RL32240_20110222.pdf.

Department of Transportation. "The Informal Rulemaking Process." February 2, 2010. http://regs.dot.gov/informalruleprocess.htm.

Bridget Dooling. "Legal Issues in e-Rulemaking." *Administrative Law Review* 4, no. 63 (2011): 892-932.

Executive Order 12866. *Federal Register* 58, no. 190 (September 30, 1993). http://www.plainlanguage.gov/populartopics/regulations/eo12866.pdf.

Arthur Fraas and Randall Lutter. "On the Economic Analysis of Regulations at Independent Regulatory Commissions." *Administrative Law Review* 63 (2011).

Government Accountability Office. "Congressional Review Act (CRA) FAQs." http://www.gao.gov/legal/congressact/cra_faq.html.

Robert W. Hahn and Cass R. Sunstein. "A New Executive Order for Improving Federal Regulation? Deeper and Wider Cost–Benefit Analysis." *University of Pennsylvania Law Review* 1,489, no. 150 (2002): 1531–37.

Michael Herz. "The Rehnquist Court and Administrative Law." *Northwestern University Law Review* 297, no. 99 (2004): 368-81.

Jeffrey S. Lubbers. *A Guide to Federal Agency Rulemaking.* 4th ed. Chicago: American Bar Association, 2006.

Thomas Merrill."Rethinking Article I, Section 1: From Nondelegation to Exclusive Delegation." *Columbia Law Review* 8, no. 104 (2004): 2,097-181.

Office of Management and Budget. "Current Regulatory Plan and the Unified Agenda of Regulatory and Deregulatory Actions." http://www.reginfo.gov/public/do/eAgendaMain.

Cass R. Sunstein. "Information Collection Under the Paperwork Reduction Act." Memorandum for the Heads of Executive Departments and Agencies, and Independent Regulatory Agencies. Office of Management and Budget. April 7, 2010. http://www.white house.gov/sites/default/files/omb/assets/inforeg /PRAPrimer_04072010.pdf.

For information on regulations under development, visit http://www .regulations.gov.

For information on regulatory oversight at the Office of Information and Regulatory Affairs, visit http://www.whitehouse.gov/omb /inforeg_default/.

For information on regulatory oversight at the Small Business Administration Office of Advocacy, visit http://www.sba.gov/ advocacy.

5

THE BUREAUCRACY: WHO IS BEHIND THE CURTAIN?

I N 2012, CLOSE to 300,000 full-time federal employees are devoted to issuing and enforcing regulations. As figure 5 shows, this number reflects a more than five fold increase in the size of the regulatory bureaucracy since 1960. Growth in the "social" (environment, safety, and health) agencies is responsible for most of the staffing increase, particularly beginning in the 1970s, when several new regulatory agencies (notably the EPA and OSHA) were established. During that decade, regulatory agencies added over 55,000 full-time staff, a 62 percent increase.

During the early 1980s, personnel declined by 13 percent, but increases in the latter part of the decade brought staffing above 1980 levels again by 1990. Staffing increased by about 15 percent during the 1990s. In the next decade, the September 11 attacks increased the focus on homeland security and led to another large increase in regulatory activity and staffing. The 56,000 new employees brought on as airport screeners under the auspices of the Transportation Security Administration caused a 31 percent jump in federal

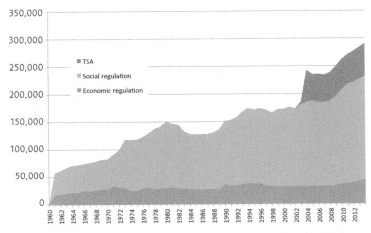

Source: Dudley and Warren, Growth in Regulators' Budget, 12. Derived from the Budget of the United States Government and related documents, various fiscal years.

Note: This figure excludes personnel responsible for regulating the terms of government funding, such as those involved with regulations implementing Medicaid, Medicare, and Social Security.

regulatory staffing between 2002 and 2003.[35] The fiscal year 2013 budget calls for a level of staffing that is 20 percent higher than it was in 2003.

This chapter briefly examines the federal bureaucracy and why it has increased in size over the last few decades.

A PUBLIC CHOICE VIEW OF BUREAUCRACY

OVER THE LAST 50 years or so, economists and political scientists have applied the theories of the firm to government systems. Not surprisingly, they have concluded that bureaucrats are like other people: they are interested in their own well-being and respond to incentives inherent in the structure of the workplace.

35. Whether Transportation Security Administration screeners should be considered regulators is an open question. They replaced private security screeners after September 11, 2011, and could be considered police (which are not usually counted as regulators) or inspectors (which are).

In his primer on public choice, Gordon Tullock makes the following observation:

> We must accept that in government, as in business, people will pursue their own private interest, and they will achieve goals that are reasonably closely related to those of the stockholders or of the citizens only if it is in their private interest to do so. Of course, this penchant does not mean that most people, in addition to pursuing their private interests, have no charitable instincts or tendencies to help others and to engage in various morally correct activities. Yet, the evidence seems strong that these are not motives upon which we can depend for the motivation of long-continued efficient performance.[36]

He suggests that bureaucracy grows because a larger agency increases workers' chances of promotion and control. A larger agency thus serves bureaucrats' private interests. Tullock recognizes that salary and power are not the only motivations, however, and that institutional incentives influence the behavior of individuals in government agencies just as they do individuals employed in the private sector.

In his book *Bureaucracy: What Government Agencies Do and Why They Do It*, James Q. Wilson identifies three types of regulatory employees. The "careerist" expects to spend his career at the agency, so his incentives are to see the agency expand and grow. The "politician" sees the agency as a stepping stone for her future career, so her incentives are to gain the support of (or at least not alienate) interest groups. The "professional"

36. Gordon Tullock et al., *Government Failure: A Primer in Public Choice* (Washington, DC: Cato Institute, 2002).

identifies with a set of skills, rather than with a particular agency, and may have incentives to expand or exhibit technical expertise.[37]

GATEKEEPERS AND EXORCISTS IN RISK REGULATION

HOW INSTITUTIONAL FRAMEWORKS and incentives affect the behavior of regulatory officials is perhaps best illustrated with the case of risk regulation. Peter Huber identified two basic approaches to regulating risks. One calls for "gatekeepers," whose job it is to keep new risks from being introduced, and the other for "exorcists," whose job it is to remove existing risks.[38] The Toxic Substances Control Act (TSCA), for example, takes a gatekeeper approach to any production of a "new" chemical by requiring the EPA to screen and preapprove new uses. TSCA gives the EPA the role of exorcist, however, when it comes to existing chemicals, which the agency may ban or otherwise regulate if it determines they present an unacceptable risk. Huber notes that these two approaches provide different incentives and yield different outcomes.

Risk regulators face two possible types of errors: (1) permitting the production of a product with unanticipated risks, and (2) not permitting a safe product. Huber showed that under a gatekeeper regime, regulators are likely to err in the direction of disapproving or delaying approval of new products. This bias against approval is a clear outcome of the gatekeeper's incentives. If a gatekeeper approves a product that later turns out to have adverse effects, she risks being dragged before Congress and pilloried by the press. On the other hand, since the potential benefits of a new product or technology

37. James Q. Wilson, *Bureaucracy: What Government Agencies Do and Why They Do It* (New York: Basic Books, 1989).

38. Peter Huber, "Exorcists vs. Gatekeepers in Risk Regulation," *Regulation* (November/December 1983): 2332.

are not widely known, the risks of disapproval (or delays in approval) are largely invisible, so the consequences of delay are less severe.

Regulators who must examine and exorcise risks from existing products face different incentives. Unlike new products, existing products already have a constituency of both producers and consumers who value the product. The risks are known, and possibly less frightening, and the benefits are also clearly visible. As a result, exorcist regulation tends to weigh the product's risks against its benefits in making decisions about restrictions or bans.

WHERE YOU STAND DEPENDS ON WHERE YOU SIT

JUSTICE STEPHEN BREYER observed in his 1993 book *Breaking the Vicious Circle* that "well-meaning, intelligent regulators, trying to carry out their regulatory tasks sensibly, can nonetheless bring about counterproductive results." Breyer referred to this institutional phenomenon as "tunnel vision," when agencies single-mindedly pursue a particular goal to the point that "the regulatory action imposes high costs without achieving significant additional safety benefits."[39] As Rufus Miles (an alumnus of the OMB's predecessor, the Bureau of the Budget) famously said, "Where you stand depends on where you sit."

Each department or agency behaves as if its mission were the most important to the country, and each has its own culture that has evolved over time.[40] The different cultures can clash,

39. Stephen Breyer, *Breaking the Vicious Circle: Toward Effective Risk Regulation* (Cambridge, MA: Harvard University Press, 1995).

40. Christopher C. DeMuth and Douglas H. Ginsburg, "White House Oversight of Agency Rulemaking," *Harvard Law Review* 99, no. 5 (1986): 1075–88; Susan E. Dudley, "Lessons Learned, Challenges Ahead," *Regulation and Governance* 32, no. 2 (Summer 2009): 6–11, http://www.cato.org/pubs/regulation/regv32n2/v32n2-1.pdf.

and alliances and animosities among career staff have hardened over years and sometimes decades of repeat interactions.[41]

Regulators, like all of us, are motivated by a complex mix of incentives and institutions. Understanding those motives can provide some insight into not only regulators' behavior, but also the form and content of the regulations they issue and how they enforce them.

41. Ibid.

FURTHER READING

Stephen Breyer. *Breaking the Vicious Circle: Toward Effective Risk Regulation*. Cambridge, MA: Harvard University Press, 1995.

Susan E. Dudley. "Regulatory Reform: Lessons Learned, Challenges Ahead." *Regulation* 32, no. 2 (Summer 2009): 6–11. http://www.cato.org/pubs/regulation/regv32n2/v32n2-1.pdf.

Peter Huber. "Exorcists vs. Gatekeepers in Risk Regulation." *Regulation* 7, no. 6 (November/December 1983): 23–32. http://www.cato.org/pubs/regulation/regv7n6/v7n6-4.pdf. See also: Huber. "The Old-New Division in Risk Regulation." *University of Virginia Law Review* 6, no. 69: 1,025-107.

Gordon Tullock et al. *Government Failure: A Primer in Public Choice*. Washington, DC: Cato Institute, 2002.

James Q. Wilson. *Bureaucracy: What Government Agencies Do and Why They Do It*. New York: Basic Books, 1989.

6

ECONOMIC REGULATION: PRICE, ENTRY, AND EXIT

*This chapter was written with Jerry Ellig,
a senior research fellow at the Mercatus Center
at George Mason University.*

WHAT IS ECONOMIC REGULATION?

IN A MARKET economy, individual firms make decisions about what to produce, how much to produce, how much to charge, and what inputs to use. Consumers and workers decide how much to spend, how much to save, how much to work, and what to buy. Through the interaction of supply and demand, markets allocate goods and services to their highest and best uses.

Economic regulation is the use of government power to restrict the decisions of economic agents. These regulations are often industry-specific. The SEC, the FCC, and the Federal Energy Regulatory Commission are examples of agencies that issue economic regulations. They regulate a broad base of activities in particular industries using economic controls such as price

ceilings or floors, quantity restrictions, and service parameters.

Economic regulation is often justified by concerns of "natural monopoly"—where a market can be served at lowest cost by a single supplier. Economic regulation generally controls the following:

1. **price**, by setting a maximum (if the concern is that a monopolist would set prices too high) or minimum (if the concern is "predatory pricing" to discourage competition)

2. **quantity**, by limiting the amount of a good or service that can be produced (e.g., state limits on crude oil production through the early 1970s) or by requiring that all demand be met at a particular regulated price (e.g., electric utilities)

3. **service quality** (particularly when price is regulated)

4. the **number of firms**, by limiting new entrants and prohibiting existing firms from exiting a market

If the firm with monopoly power charges a price that exceeds the price it would charge if it faced competition, ideal regulation can mimic the results of competition and force the firm to charge the "competitive" price. In this situation, regulation has two beneficial effects for consumers. First, consumers who were already buying the service receive it at a lower price; the gains to these consumers can be measured by the amount of the price reduction multiplied by the amount they were already buying at the monopoly price. Second, the lower price induces consumers to purchase more, and this increased consumption further increases consumer welfare. Conceptually, this gain to consumers is equal to the difference between the regulated price the consumer pays and the price the consumer

would have been willing to pay, summed over all the additional units consumed.

PROBLEMS WITH ECONOMIC REGULATION

REGULATION IS INTENDED to make consumers better off by producing a price equal to the competitive market price. However, there is no guarantee of this result for at least five reasons:

1. Prices below competitive market levels can create shortages.

2. Regulation can hold prices above costs.

3. Regulation inflates costs.

4. Regulation stifles innovation and entrepreneurship.

5. Expenditures to acquire and maintain wealth transfers increase costs.

Let us examine each of these reasons in detail.

Below-Competitive Prices

IF REGULATORS SET prices below the competitive level, they create shortages. History suggests that regulators frequently succumb to this temptation. The temptation is especially strong in capital-intensive industries that require high up-front investments that have few good alternative uses. For example, natural gas price regulations in the 1960s were an explicit attempt to transfer profits from gas producers to consumers, but fixing prices below competitive prices resulted

in shortages. After the investment is made, public policy can reduce prices below the competitive level without immediately creating a shortage as long as the prices are high enough to cover the firm's ongoing (variable) costs of operation. Such prices harm consumers in the long run because firms will refrain from investing if they expect the inadequate prices to continue. Eventually, this reduction in investment creates shortages, deteriorations in service quality, or other problems that diminish consumer welfare.

Above-Competitive Prices

PRICE AND ENTRY regulations imposed on a competitive industry can actually increase prices and reduce consumption. This result can occur when policymakers mistakenly impose regulation on a competitive industry or when they consciously impose regulation in response to political incentives. For example, price and entry were regulated in the airline market through the late 1970s, which resulted in government-enforced cartels that kept average airfares above competitive levels.

As discussed in chapter 2, political incentives to regulate a competitive industry could come from the industry itself, which may seek regulation to forestall competition and increase profits. But political pressures may also come from customers who use regulation to obtain service at subsidized rates, with the subsidies funded through excessive charges imposed on other consumers.

When regulation elevates prices above costs, it reduces consumer welfare both by increasing prices and by reducing output. Cross-subsidies can reduce producer welfare as well. If a monopolist is allowed to overcharge to fund cross-subsidies, the firm sacrifices some or all of the inflated profits. If regulators force competing firms to overcharge consumers and then

hand the money to some other firm to subsidize its service, the firms forced to collect the excess charges will see their sales and profits fall in response to the price increase. This latter example may appear fanciful in the abstract, but it is precisely what happens through the FCC's "intercarrier compensation" and Universal Service Fund schemes, which require that telephone (and soon broadband Internet) rates in "high cost" areas, such as rural areas, be comparable to those in urban areas. To equalize costs, the FCC subsidizes high-cost providers with fees levied on all telephone subscribers.

Inflated Costs

COST-OF-SERVICE REGULATION OFTEN distorts the regulated firm's choice of inputs, so the regulated firm is unable to produce at minimum cost. The resulting rates might be considered "just and reasonable" because they reflect costs, but the costs themselves will be inflated. Competition pressures firms to squeeze out unnecessary costs and to provide a combination of price and quality that consumers prefer. Where monopoly is expected to persist, both federal and state regulators have increasingly opted for "price cap" regulation, which limits the prices firms can charge but allows them to earn additional profits by cutting costs.

Stifled Innovation and Entrepreneurship

REGULATION DIMINISHES ENTREPRENEURIAL incentives to lower costs, improve quality, and develop new products and services. Empirical studies of deregulated, competitive industries demonstrate the impact of innovation, for such studies consistently find that deregulation generates larger price reductions than economists predict based on pre-deregulation costs and market conditions.

Regulatory constraints on profits reduce the rewards for risky but potentially valuable innovation. In theory, regulators could prevent this problem by permitting the firm to earn a sufficient risk premium. In practice, regulators face a continual temptation to disallow the risk premium once an innovation is introduced and proven successful because the successful innovation will likely remain in place even if regulation reduces its profitability. After the fact, it is often difficult to distinguish between high profits resulting from innovation and high profits resulting from market power. Expropriating these profits, however, reduces incentives for future innovation. And if profit regulation removes the carrot, protected markets remove the stick—the competitive threat that could otherwise spur entrepreneurship.

In addition to altering incentives for discovery, economic regulation short-circuits the market's normal trial-and-error process. The purpose of competition is to reveal what services, costs, and prices are possible. As Justice Breyer noted in his dissent in *AT&T Corp. v. Iowa Utilities Board*, a key case interpreting the Telecommunications Act of 1996, "The competition that the Act seeks is a process, not an end result; and a regulatory system that imposes through administrative mandate a set of prices that tries to mimic those that competition would have set does not thereby become any the less a regulatory process, nor any the more a competitive one."[42]

If there is no competitive market, actual competitive prices cannot be observed, but public policy often assumes that regulators can estimate prices tolerably close to those that a competitive market would have generated if it existed. In the absence of competition, however, we do not know for sure what services, costs, and prices are possible; to estimate what

42. AT&T Corp. v. Iowa Utilities Board, 525 U.S. 366 (1999), 418–21 (J. Breyer, concurring in part and dissenting in part).

competitive prices would be, these things must be assumed, and the assumptions may be wrong. In a very static industry, historical costs may be a useful guide for calculating "competitive" prices. In a dynamic industry, though, attempts to estimate competitive prices that do not actually exist will be fraught with error.

Regulation can also stifle innovation more directly when firms must obtain regulators' permission before entering new markets or offering new services. In some cases, firms must wait for regulators to establish a legal or institutional framework before they can deploy a new technology. For example, according to one study, the 10-year delay in allowing local Bell telephone companies to offer voice mail cost consumers approximately $1.27 billion annually, and regulation-induced delay in the introduction of cell phone service cost consumers $50 billion annually in forgone benefits.[43]

Expenditures to Acquire/Maintain Wealth Transfers

WHETHER IT CURBS or creates market power, regulation transfers wealth. The fact that regulation is a means of transferring wealth also implies another effect on the welfare of both consumers and the regulated industry. When wealth transfers are available, organized interests will expend resources to obtain them. Regulated firms will spend money to retain monopoly profits or to protect themselves from below-competitive prices that expropriate their assets. From a society-wide perspective, money spent to capture wealth transfers is pure waste. It is even conceivable that the total amount of money wasted may exceed the size of the wealth transfer.

43. Jerry A. Hausman, "Valuing the Effect of Regulation on New Services in Telecommunications," *Brookings Papers on Economic Activity, Microeconomics* (1997).

TRENDS IN ECONOMIC REGULATION

THE INTERSTATE COMMERCE Commission (ICC), the first federal regulatory agency in U.S. history, was established by the Interstate Commerce Act of 1887 to regulate rail-shipping rates. Economic regulation grew rapidly from the early 1900s through the early 1970s. By the 1970s and 1980s, the tide had turned, however, and the legislative, executive, and judicial branches moved to deregulate industries once thought of as natural monopolies, including airlines, oil and gas production, trucking, railroads, and telephones. The ICC was among the agencies abolished by these deregulatory initiatives in 1995.

The move toward deregulation was driven in part by a large body of literature showing that regulation did not serve the public interest, as discussed above and in chapter 2. Many markets once thought of as "natural monopolies" have proved quite competitive.

Transportation and energy deregulation in the 1970s and 1980s are generally regarded as successes, having lowered consumer prices and increased choices. Deregulation and consumer choice have aligned service quality with customer preferences. Competitive markets have generated real gains and not just reallocated benefits for consumers and society as a whole, and markets have evolved in beneficial ways that were not anticipated before deregulation.

Other economic deregulation initiatives have been viewed as failures. For example, when savings and loans were freed to invest in assets other than home mortgages in the 1980s, many went bankrupt. They gambled on risky investments, knowing that federal deposit insurance would bail out depositors if the investments went bad. And when California deregulated wholesale electric rates and forced its utilities to buy all their power in short-term market transactions, prices spiked after a dry

winter reduced the availability of cheap hydroelectric power. The lesson here is that policymakers should carefully consider the interplay of incentives and unintended consequences when partially deregulating industries that have complex relationships with parts of the system that remain regulated.

Recent years have seen a resurgence of economic regulation. For example, the PPACA is in many ways a cross-subsidy program to transfer wealth from one group to another. Once fully implemented through regulation, the law will require the insurance market to provide coverage that it otherwise would not, as it already does by requiring insurers to cover 26-year-old dependent adults who remain on their parents' health insurance policies. The law will eventually require everyone to buy insurance at higher rates to pay for the subsidies. This scheme is not unlike the FCC's Universal Service Fund regulations described earlier.

The Internet has also seen increasing regulatory activity. Most notably, the FCC has adopted "net neutrality" rules to prevent Internet service providers from using market power to unreasonably discriminate among data traffic on their networks. Other regulatory efforts have addressed privacy, cybersecurity, and piracy. While cybersecurity can be seen as a public good best understood through the lens of social regulation, other attempts to regulate the Internet can be characterized as "consumer protection" regulation. Regulators want to correct perceived information asymmetries between consumers and social networks, search engines, and other content providers.

Direct price controls have also seen a revival. The PPACA includes provisions that require states and the federal government to review annual insurance rate increases in excess of 10 percent. Additionally, new regulations required by the Wall Street Reform and Consumer Protection Act limit the

fees banks can charge merchants each time a consumer makes a debit card purchase.[44] Banks, in turn, have raised the service fees they charge consumers.[45]

44. Todd J. Zywicki, "The Dick Durbin Bank Fees," *Wall Street Journal*, November 30, 2011, A15.

45. Ibid.

FURTHER READING

Robert Crandall and Jerry Ellig. *Economic Deregulation and Customer Choice: Lessons for the Electric Industry.* Washington, DC and Fairfax, VA: Brookings Institution and Center for Market Processes, 1997. http://mercatus.org/sites/default/files/publication/MC_RSP _RP-Dregulation_970101.pdf.

Martha Derthick and Paul J. Quirk. *The Politics of Deregulation.* Washington, DC: Brookings Institution, 1985.

The Dodd-Frank Wall Street Reform and Consumer Protection Act of 2010. 15 U.S.C. § 78 (2010).

Susan E. Dudley. "Alfred Kahn, 1917–2010." *Regulation* 34, no. 1 (Spring 2011): 8–12. http://www.cato.org/pubs/regulation/regv34n1 /regv34n1-2.pdf.

Lynne L. Kiesling and Andrew N. Kleit. *Electricity Restructuring: The Texas Story.* Washington, DC: AEI Press, 2009.

Israel Kirzner. "The Perils of Regulation: A Market Process Approach." In *Discovery and the Capitalist Process*, 119-49. Chicago: University of Chicago Press, 1985.

Brian Mannix. *Regulatory Subsidies: A Primer.* Washington DC: GW Regulatory Studies Center, 2012. http://www.regulatorystudies.gwu. edu/images/pdf/20120313_mannix_regsubsidies.pdf.

The Patient Protection and Affordable Care of 2010. Pub. L. No. 111-148, 124 Stat. 119 (2010).

Sam Peltzman and Clifford Winston, eds. *Deregulation of Network Industries: What's Next?* Washington, DC: Brookings Institution, 2000.

Clifford Winston."Economic Deregulation: Days of Reckoning for Microeconomists." *Journal of Economic Literature* 31, no. 3 (1993): 1263–89.

7

SOCIAL REGULATION: HEALTH, SAFETY, AND ENVIRONMENT

WHILE ECONOMIC REGULATIONS dominated administrative law in the first half of the 20th century, social regulations have driven the increase in regulatory activity since the late 1960s.[46] Social regulations are designed to address issues related to health, safety, security, and the environment. The Environmental Protection Agency, the Occupational Safety and Health Administration, the Food and Drug Administration, and the Department of Homeland Security are examples of agencies that administer social regulations. Their activities are generally limited to a specific issue, but they also have the power to regulate across industry boundaries.

As discussed in the previous chapter, the normative public interest justification for many economic regulations is to control the prices set by "natural monopolies." The normative

46. Bruce Yandle, "National TV Broadcasting and the Rise of the Regulatory State," *Public Choice* 142, no. 3–4 (2010): 339–53.

justification for social regulations is often "externalities" or "information asymmetries." This chapter examines these "market failure" justifications; explores the concept of risk as the focus of many health, safety, and environmental regulations; and presents an array of regulatory approaches for addressing these problems.

EXTERNALITIES, PROPERTY RIGHTS, AND COMMON LAW

ENVIRONMENTAL POLLUTION IS the classic example of an externality. Consider the textbook case of an upstream factory that pollutes water used for recreation downstream. The costs of disposing of the waste in the stream are not accounted for by the factory owner and are not factored into the price consumers pay for the factory's product. Instead, they are borne by recreational users downstream.

Early in the 20th century, British economist A. C. Pigou studied this problem and proposed government solutions to internalize such externalities. His solution has become known as a Pigouvian tax—a tax imposed per unit of pollution. (The end of this chapter explores taxes and other regulatory approaches further.)

In 1960, Nobel Prize-winning economist Ronald Coase offered a different perspective on externalities. He showed that externalities emerge as a result of poorly defined property rights or high transaction costs, and that as long as property rights are established and transaction costs are low, parties involved in disagreements can negotiate a solution that internalizes any externality. In the case of the polluting factory and the downstream recreational users, if the recreationists owned the property rights to the stream, the factory owner would have to negotiate with them to discharge waste into the stream.

The solution they might reach would depend on the two parties' costs to abate or mitigate damages, but could entail the factory's paying the recreationists to swim or fish somewhere else, compensating them for the diminished water quality, limiting its waste, or completely shutting down.

Several interesting insights emerge from Coase's work. First, he showed that an externality is a cost jointly produced by the conflicting activities of both parties. In our example, the "reciprocal problem" is due to a conflict between the factory owner's and recreationists' conflicting uses of the stream.

A second key insight is that in the absence of transaction costs, it does not matter who has the property rights. Whether the factory owner must compensate the recreationist to continue to pollute or the recreationist must pay the factory owner to reduce its discharge, the externality is internalized with established property rights and the ability to negotiate freely.

A third point worth noting is that Coasian solutions negotiated between affected parties are based on the "particular circumstances of time and place," whereas regulated solutions tend to be one-size-fits-all.

Before statutory law attempted to address externalities through regulation, solutions like those envisioned by Coase were often negotiated between individuals and enforced through common law—the legal rules and traditions that developed over time through court decisions. Ordinary citizens were able to protect their land and water through legal actions against trespass and nuisance.

Some scholars argue that such common law approaches were superior to statutory law because individuals could hold accountable someone who allowed a "nuisance" like pollution to invade their property.[47] Under a regulatory environment, as

47. Bruce Yandle, *Common Sense and Common Law for the Environment* (Lanham, MD: Rowman & Littlefield, 1997), 87–118.

long as a polluter obeys legal standards, damaged third parties cannot demand compensation.

Others argue that in the real world, transaction costs are usually large enough to prevent efficient bargaining between parties. Thus, externalities such as pollution tend to be addressed through statutory law.

Nevertheless, Coase's insights are valuable for informing decisions about regulatory alternatives and the analysis of regulatory impacts because they give policymakers additional tools to resolve externality problems. In some cases, government can facilitate voluntary solutions by clarifying property rights or by reducing transaction costs.

REGULATING RISKS

ENVIRONMENTAL, HEALTH, SAFETY, and homeland security regulation tends to be aimed at reducing risk of sickness, death, or injury. However, regulations cannot eliminate all risk. Everything we do involves risk, whether we choose to go for a jog, drive a car, or lie in bed all day. We are willing to accept risks because the actions that involve the risks also provide benefits. For example, when you drive a car to work, you run the risk of being hurt in a car accident, but avoid the risk of being hurt on a bicycle or in a train accident. Moreover, you gain the benefit of getting to work in a convenient manner, freeing up time for other pursuits.

Since it is impossible to eliminate all risk, regulators attempt to focus regulatory activity on the most significant risks. However, they are not always successful. In 1987, the EPA ranked its regulated activities according to the risks they posed to human health and the environment. It found that the activities that commanded the largest share of federal resources and public dollars were not the ones that posed the greatest risks.

For example, the management of hazardous waste and the cleanup of chemical waste sites ranked relatively low on the risk scale, but high on the effort scale. It turned out that the allocation of resources tracked public perception of risks very well, but these perceptions did not reflect reality.

This phenomenon can also be seen on a global scale. Since 2004, the Copenhagen Consensus—a panel of experts including several Nobel laureates—has ranked world problems based on how cost-effectively they could be addressed. Addressing climate change, to which governments devote great resources, consistently ranks low on the group's list of world problems to address after considering costs and benefits. Malnutrition and HIV/AIDS top the experts' list, but are rarely government priorities.[48]

Numerous studies have shown that a reallocation of current spending from lower risk to higher risk problems could greatly improve the life-saving results of regulations designed to reduce health and safety risks, even if each agency continued to impose the same total regulatory costs but merely targeted its efforts more efficiently. Misdirected regulatory efforts not only pass over opportunities for greater risk-reduction benefits, but by imposing unnecessary costs, they can actually increase health risks by lowering incomes. The positive correlation between income and health has long been recognized; not only are life expectancies longer and health better in wealthier nations, but wealthier individuals within nations tend to be healthier and live longer.

Thus, the key questions for risk regulation are, "To what extent does the regulation reduce risks?" and "At what costs?" Answering these questions requires two phases of analysis—"risk assessment" and "risk management"—first laid out in

48. Bjørn Lomborg, "An Economic Approach to the Environment," *Wall Street Journal*, April 24, 2010, A13.

a framework established by the National Research Council (NRC) in 1983:

> Regulatory actions are based on two distinct elements, risk assessment... and risk management. Risk assessment is the use of the factual base to define the health effects of exposure of individuals or populations to hazardous materials and situations. Risk management is the process of weighing policy alternatives and selecting the most appropriate regulatory action, integrating the results of risk assessment with engineering data and with social, economic, and political concerns to reach a decision.[49]

This distinction should not be interpreted to suggest that the disciplines involved in the risk management phase have no "factual base." Rather, it attempts to differentiate positive analysis (what risks are present) from normative analysis (how should they be addressed). Even in the risk assessment phase of an analysis, scientists will never have complete information to predict outcomes with absolute certainty. Risk assessors rely on what the NRC calls "risk assessment policy"—assumptions, judgments, and rules of thumb—to guide the use of scientific information in analyses that inform policy in the face of uncertainty.

> In each step [of the risk assessment process], a number of decision points (components) occur where risk to human health can only be inferred from the available evidence. Both scientific judgments and policy choices may be involved in selecting from

49. National Research Council and the Committee on the Institutional Means for Assessment of Risks to Public Health, *Risk Assessment in the Federal Government: Managing the Process* (Washington, DC: National Academies Press, 1983).

among possible inferential bridges, and we have used the term risk assessment policy to differentiate those judgments and choices from the broader social and economic policy issues that are inherent in risk management decisions.[50]

Figure 7 illustrates the NRC's distinction between risk assessment and risk management.

FIGURE 7: RISK ASSESSMENT AND RISK MANAGEMENT

Source: Author's illustration.

Risk assessment is necessary but rarely sufficient for establishing effective policy to address identified risks. Sound policy decisions must also weigh other factors, such as those related to economics, engineering, ethics, law, and politics. What factors regulators consider in this risk management phase depends on statutory as well as executive directives such as the following:

- risk–risk analysis to compare the risks targeted by the regulation to the risks that may arise from a substitute product or activity;

- cost-effectiveness analysis, which compares the costs of

50. Ibid.

different approaches against a metric such as life-years saved or tons of a pollutant removed; and

- benefit-cost analysis, which attempts to quantify and assign dollar values to the benefits of different approaches, as well as costs.

REGULATORY APPROACHES

REGULATORY APPROACHES TO addressing health, safety, security, and environmental quality come in different forms.

Technology-based regulations, such as requirements that all smokestacks be equipped with scrubbers, dictate the mechanism by which a regulated entity must comply. While having advantages for enforcement (it is easy to determine whether the appropriate control has been applied), command-and-control regulations discourage innovation and do not adapt to different circumstances. For example, mandating scrubbers diminishes incentives to reduce emissions in different ways, such as by using cleaner sources of fuel.

Performance-based standards, such as limiting emissions to a certain level, are superior to technology-based standards in that they allow regulated entities to experiment with different methods of achieving regulatory goals. They also encourage innovation and efficiency.

Economists widely prefer regulations that contain **economic incentives** over less flexible regulatory approaches. The acid rain program of the 1990 Clean Air Act Amendments, for example, allocated tradable permits to electric utilities that allowed them to emit one ton of sulfur dioxide over a year. Utilities

were allowed to trade those permits, so utilities with below-average costs for reducing SO_2 emissions undertook control measures and freed up permits to sell to utilities with above-average reduction costs. These marketable permits, along with pollution fees or taxes, are patterned after the Pigouvian model of internalizing externalities.[51]

A clear definition of property rights (along the Coasian model) is employed less frequently, though patents for new medical products address the "public good" aspect of innovation by allowing inventors to defend property rights to their innovations. The opportunity to profit motivates innovation.

Radio spectrum licenses used for broadcasting, wireless communications, and other applications provide another illustration of property rights substituting for top-down regulation. Spectrum is a scarce resource, like oil or timber. There are more competing uses for the resource than there is resource to go around. Oil and timber are allocated among their competing uses through markets. Spectrum, on the other hand, has traditionally been allocated through regulation. The federal government, however, has recently begun to employ property rights and markets to allocate spectrum. The FCC issues licenses that define quasi-property rights in spectrum bands and those licenses are auctioned. Wireless broadband providers and other licensees later trade them in secondary markets.

Disclosure regulations, which have the virtue of allowing consumers to make their own choices, are one way regulators sometimes address the problem of asymmetric information by supplying missing information. For example, energy

51. Pigou did not actually contemplate marketable permits but rather taxes to internalize externalities. Marketable permits also respond to Coase's insight by defining enforceable property rights.

efficiency labels inform consumers of the expected operating costs of different appliances. The challenges in crafting disclosure regulations are determining how consumers will interpret the information and ensuring the mandated information is not misleading.

TRENDS IN SOCIAL REGULATION

REGULATORY REFORM IS always a topic of debate in policy circles. However, in contrast to the consensus on economic restrictions on prices, quality, or quantities, where "reform," equated to "deregulation," the focus in the social regulatory area is on reforms to make regulations less burdensome and more cost-beneficial. Recent reforms have pursued "smarter" or "better" regulations by changing the procedures and decision-making criteria used to develop new regulations and re-evaluate existing ones. These efforts often depend on quantitative regulatory analysis, the subject of the next chapter.

FURTHER READING

Ronald Coase. "The Problem of Social Cost." *Journal of Law and Economics* 3 (October 1960): 1–44. http://www.sfu.ca/~allen/CoaseJLE1960.pdf.

Susan E. Dudley and George M. Gray. "Improving the Use of Science to Inform Environmental Regulation." In *Institutions and Incentives in Regulatory Science*, edited by Jason Scott Johnston (Lanham, MD: Lexington Books, 2012.

Susan E. Dudley and Sharon Hays. "Updated Principles for Risk Analysis." Memorandum for the Heads of Executive Departments and Agencies, Office of Management and Budget. September 19, 2007. http://www.whitehouse.gov/sites/default/files/omb/assets/omb/memoranda/fy2007/m07-24.pdf.

Environmental Protection Agency. "Unfinished Business: A Comparative Assessment of Environmental Problems." February 1987. http://yosemite.epa.gov/water/owrccatalog.nsf/0/d8555a5ca86d824a85256b06007256d1?OpenDocument.

Bjørn Lomborg, ed. *Solutions for the World's Biggest Problems: Costs and Benefits*. Cambridge: Cambridge University Press, 2007.

John F. Morrall. "Saving Lives: A Review of the Record." *Journal of Risk and Uncertainty* 27, no. 3 (2003): 221–37.

A. C. Pigou. *Economics of Welfare*. New Brunswick: Transaction, 2009.

Cass R. Sunstein. "Informing Consumers Through Smart Disclosure." Memorandum for the Heads of Executive Departments and Agencies. Office of Management and Budget. September 8, 2011. http://www.whitehouse.gov/sites/default/files/omb/inforeg/for-agencies/informing-consumers-through-smart-disclosure.pdf.

Tammy O. Tengs and John D. Graham. "The Opportunity Cost of Haphazard Social Investments in Life-Saving." In *Risks, Costs, and Lives Saved: Getting Better Results from Regulation*, edited by R. Hahn, New York: Oxford University Press, 1996.

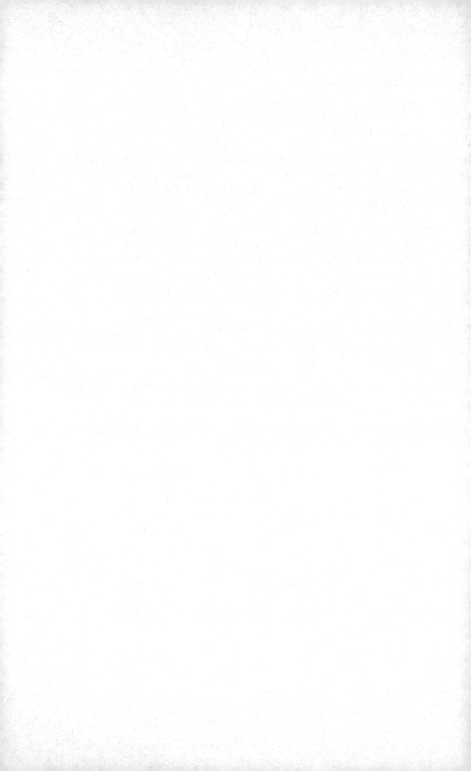

8

REGULATORY ANALYSIS

A s THE VOLUME of regulatory activity has grown, so has the analysis and oversight that accompanies new regulations. This chapter outlines generally accepted principles for addressing the normative question of when and how we *should* regulate. These principles follow those in Executive Order 12866, which has guided regulatory development since 1993.[52]

In the simplest terms, the goal of regulatory analysis is to present information to decision-makers to ensure that a proposed regulation does more good than harm. Figure 8 schematically shows the steps in a regulatory analysis.

52. For a more comprehensive discussion of regulatory analysis principles, see Office of Management and Budget, Circular A-4, September 17, 2003, http://www.whitehouse.gov/omb/circulars_a004_a-4/. For a concise summary of the key elements described in Circular A-4, see Office of Information and Regulatory Affairs, *Regulatory Impact Analysis: A Primer*, http://www.whitehouse.gov/sites/default/files/omb/inforeg/regpol/circular-a-4_regulatory-impact-analysis-a-primer.pdf.

Source: *Author's illustration.*

The first condition, presence of a market failure or other systemic problem, is necessary but not sufficient to demonstrate that a regulation may have benefits to Americans in excess of its costs. If this condition exists, the analyst should first examine nonregulatory solutions, taking into consideration the remaining questions, before considering regulation. If regulation is deemed necessary, an approach should be chosen that maximizes net benefits, relies on the best available information, and takes into account how effects are distributed and the effect of the regulation on individual choices and rights. Let us examine this process in greater detail.

1. IDENTIFY A SIGNIFICANT MARKET FAILURE OR SYSTEMIC PROBLEM.

E.O. 12866 EXPRESSES the following "regulatory philosophy":

> Federal agencies should promulgate only such regulations as are required by law, are necessary to

interpret the law, or are made necessary by compelling public need, such as material failures of private markets to protect or improve the health and safety of the public, the environment, or the well-being of the American people.[53]

Markets may not work effectively at distributing resources for several reasons. First, efficient markets need an adequate infrastructure, including the rule of law, well-defined property rights, and a system of exchange. If any of these components are missing or inadequate, resources may not be allocated efficiently. Second, poorly designed policies may impede the functioning of markets. As discussed in chapter 6, economists generally agree that economic regulation of private sector prices, entry, and exit tends to distort market signals and historically has kept prices higher than necessary to the benefit of regulated industries and at the expense of consumers. Third, markets may not perform efficiently due to inherent "market failures," which, as discussed in earlier chapters, generally fall into one of four categories: (1) externalities, (2) public goods and common pool resources, (3) monopoly power, and (4) asymmetric information.

Often, the problems we observe are not due to fundamental "market failures" but rather to inadequate infrastructure or poorly designed policies. Michael Munger makes the analogy that blaming markets for inadequate infrastructure is like saying your car is a lemon because there is no road.[54] For example, some problems associated with externalities and public goods reflect the systemic problem that property rights are not defined to encompass important attributes of a property or

53. Executive Order no. 12866.

54. Michael Munger, *Analyzing Policy: Choices, Conflicts, and Practices* (New York: Norton, 2000).

action. Similarly, he says blaming markets for poorly designed policies is equivalent to blaming your car when you put maple syrup in the gas tank. For example, many industries thought to be natural monopolies in fact gained their monopoly privileges through government protections, not through inherent economies of scale. Regulatory actions that do not explicitly recognize the market failure or systemic problem underlying the need for action are bound to be less effective than those that identify and correct the fundamental problem.

2. IDENTIFY ALTERNATIVE APPROACHES.

AFTER IDENTIFYING A market failure or systemic problem, the analyst should examine a wide range of viable alternatives for addressing it. Even if a market failure can be identified, there may be no need for federal regulatory intervention if other approaches would resolve the problem adequately or better than federal regulation would. Alternatives to federal regulation include the judicial system (e.g., consumer-initiated litigation over a defective product), antitrust enforcement, and administrative compensation systems (e.g., workers' compensation provides incentives for safer workplaces, as well as compensation for injuries sustained on the job). State and local actions offer additional alternatives.

Federal regulation may be appropriate if state or local regulations would burden interstate commerce, or if it is necessary to protect the rights of national citizenship, such as civil liberties guaranteed by the Constitution. However, in general, regulations developed at the state and local levels better accommodate the diversity in citizens' local circumstances and preferences and encourage competition among governmental units to meet the needs of taxpayers and citizens.

Federal regulatory alternatives should include approaches

targeted at the fundamental market cause of the problem. For example, if asymmetric information is identified as the market imperfection of concern, solutions that provide information are most appropriate.

In general, market-based and performance-oriented approaches are preferable to command-and-control standards. By harnessing market forces, market-based approaches are likely to achieve desired goals at lower social costs than command-and-control approaches. Where regulations create private rights or obligations, they should also encourage unrestricted exchange of these rights or obligations.

Health, safety, security, and environmental regulations should address ends rather than means. Performance standards or economic incentives are more effective than technology-based standards, which by dictating the means of achieving goals discourage innovation.

Viable alternative approaches should be evaluated objectively and presented to decision-makers before they settle on any approach. An analysis conducted after a particular regulatory approach has been selected does not provide policy makers with the information necessary to make an informed and balanced decision.

3. CHOOSE THE REGULATORY ACTION THAT MAXIMIZES NET BENEFITS.

E.O. 12866 STATES that the selected regulatory alternative should be the one that maximizes net benefits to society:

> In choosing among alternative regulatory approaches, agencies should select those approaches that maximize net benefits (including potential economic, environmental, public health and safety, and other

advantages; distributive impacts; and equity), unless a statute requires another regulatory approach.[55]

The rationale for choosing a particular approach over alternatives should include a discussion of how that approach corrects the market failure or systemic problem that has been identified.

Evaluation of whether an approach meets this criterion depends on a good benefit–cost analysis with the following characteristics.

3.1 Estimates of Benefits and Costs Should Be Realistic.

ANALYSIS OF THE benefits and costs of alternative approaches to achieving regulatory goals must be conducted from a realistic and consistent baseline. According to the OMB,

> The baseline represents the agency's best assessment of what the world would be like absent the action. To specify the baseline, the agency may need to consider a wide range of factors and should incorporate the agency's best forecast of how the world will change in the future, with particular attention to factors that affect the expected benefits and costs of the rule.[56]

In most cases, the baseline should reflect the state of the world in the absence of the proposed regulation, and estimated costs and benefits should be incremental to this baseline. How will costs or benefits change if regulations are enacted? It may be useful to conduct incremental analysis from more than one possible baseline.

55. Ibid.

56. OIRA, *Regulatory Impact Analysis: A Primer*.

3.2 All Values Should Be Discounted to the Present.

ALL MONETARY VALUES for benefits and costs that occur in different years should be stated in comparable, discounted present value terms. A dollar today is worth more than a dollar tomorrow, and by putting all values in present value terms, it is simple to compare apples to apples. OMB Circular A-4 summarizes the main rationales for the discounting of future impacts:

1. Resources that are invested will normally earn a positive return. Current consumption is therefore more expensive than future consumption since you give up that expected return on investment when you consume today.

2. Postponed benefits also have a cost because people generally prefer present to future consumption. They are said to have positive time preference.

3. Also, if consumption continues to increase over time, as it has for most of U.S. history, an increment of consumption will be less valuable in the future than it would be today. The principle of diminishing marginal utility implies that as total consumption increases, the value of an additional unit of consumption tends to decline.[57]

The circular recommends that analyses rely on real, before-tax discount rates of 7 percent and 3 percent per year.[58]

57. OMB, *Circular A-4*.

58. Circular A-4 also raises the possibility of using lower discount rates for intergenerational time frames.

3.3 Benefits Should Be Quantified and Valued to the Extent Possible.

E.O. 12866 STATES, "Costs and benefits shall be understood to include both quantifiable measures (to the fullest extent that these can be usefully estimated) and qualitative measures of costs and benefits that are difficult to quantify, but nevertheless essential to consider."[59] The economic concept of *opportunity cost* is the appropriate measure of benefits as well as costs. It recognizes that, by using a resource (including your time) in a particular way (say, activity A), you give up the opportunity of using that resource elsewhere. Let's say the next best use of the resource is activity B. The opportunity cost of activity A is the value of activity B (which is foregone).

"Willingness to pay" reflects what individuals are willing to forgo for a particular benefit or outcome.[60] Market transactions are the most reliable measure of society's willingness to pay for goods and services. For goods that are not exchanged, however, statistical techniques, such as travel-cost studies and hedonic pricing models, can often be used to estimate willingness to pay for indirectly traded goods. For example, willingness to pay for recreational fishing might be measured by the costs people are willing to incur to travel to a good trout stream, or comparable housing prices might be used to estimate how much families value proximity to a recreational area. Agencies sometimes rely on "stated preference" methods, which survey people's expressed willingness to pay for things that are hard to measure directly, such as wildlife habitat. As these methods rely on responses to hypothetical questions rather than actual payments, they tend to be more subjective and less reliable than revealed preference methods that observe what people

59. Executive Order 12866.

60. Alternatively, "willingness to accept" reflects the compensation individuals would require to accept a risk or other cost.

actually pay to satisfy their preferences.

Many health and safety rules are designed to reduce premature mortality associated with accidents or exposure to environmental or workplace risks. Analyses typically rely on statistical measures of risk consequences, such as statistical lives saved or years of life saved. These studies do not refer to individual statistics, but rather measure the sum of risk reductions expected in a population. For example, if the annual risk of death is reduced by one in a million for each of two million people, that reduction is said to represent two "statistical lives" extended per year. A reduction in the annual risk of death by one in 10 million for each of 20 million people also represents two statistical lives extended.

The use of a years-of-life-saved metric is often more informative than a lives-saved metric. Lives are never "saved" but rather extended, and different actions may have different effects on life expectancy. A lives-saved metric cannot distinguish an action that extends a statistical life by 40 years from one that extends it by 6 months.[61]

As noted above, objective disclosure of underlying assumptions and values is essential to a transparent, meaningful estimate of benefits.

3.4 Costs Should Be Quantified and Valued.

THE SOCIAL COST of a regulation is not money paid by businesses or other regulated entities. The cost of a regulation is the opportunity cost—whatever desirable things society gives up in order to get the good things the regulation produces.

61. Sometimes the concept of "years of life saved" is derided as a "senior death discount" that counts elderly people's lives as less important than young people's. This interpretation is incorrect. Estimating years of life saved means that an additional year of life counts the same regardless of whether the people affected are young or old.

The opportunity cost of alternative approaches is the appropriate measure of costs. This measure should reflect the benefits foregone when a particular action is selected and should include the change in consumer and producer surplus.[62] A presidential risk commission recognized the importance of such tradeoffs, noting that risk management decisions should consider "diversion of investments, or opportunity costs—such as having to spend money on environmental controls instead of using those resources to build a school or reduce taxes."[63]

Cost estimates should include a most likely ("best") estimate of the costs as well as a range. They should also discuss the sensitivity of those estimates to key assumptions.

4. BASE THE PROPOSAL ON STRONG SCIENTIFIC OR TECHNICAL GROUNDS.

THE ANALYSIS OF benefits and costs should reflect the best scientific, technical, and economic information available. The analysis should present unbiased estimates of the most likely outcomes of different alternatives. OMB Circular A-4 states,

> A good analysis should be transparent and your results must be reproducible. You should clearly set out the basic assumptions, methods, and data underlying the analysis and discuss the uncertainties associated with the estimates. A qualified third party

62. Consumer surplus is the difference between what a consumer pays for a good and the amount she would be willing to pay. It is measured by the area between the price and the demand curve for the good. Producer surplus is the difference between the amount a producer is paid for a unit of a good and the amount he would accept to supply that unit. It is measured by the area between the price and the supply curve.

63. The Presidential/Congressional Commission on Risk Assessment and Risk Management, *Framework for Environmental Health Risk Management*, Final Report, vol. 1 (1997), 33.

reading the analysis should be able to understand the basic elements of your analysis and the way in which you developed your estimates.[64]

Recognizing that estimates of benefits and costs are uncertain, Circular A-4 asks agencies to report "the full probability distribution of potential consequences" and, where possible, to present probability distributions and upper and lower bound estimates in addition to central estimates of expected value.[65] In addition, it is useful to present the results of sensitivity analysis to communicate information on the robustness of the best estimate and the range of possible outcomes. Sensitivity analysis examines different "what if" scenarios to see how changes in key assumptions influence estimated outcomes.

When there is disagreement or uncertainty regarding particular effects or outcomes, the sensitivity of the benefits and costs of alternative actions to different assumptions should be presented clearly.[66]

For actions designed to reduce health risks, analysts must often make projections based on limited information. In these cases it is not only important to base analyses on a balanced review of the most robust data available, but to ensure that the assessment of risk is objective and not confused with policy choices. According to Circular A-4,

the risk assessment methodology must allow for the determination of expected benefits in order to be comparable to expected costs. This means that conservative assumptions and defaults (whether

64. OMB, *Circular A-4*.

65. Ibid.

66. OMB's peer review guidelines and data quality guidelines provide guidance on the use of scientific and technical data.

motivated by science policy or by precautionary instincts), will be incompatible with benefit analyses as they will result in benefit estimates that exceed the expected value. Whenever it is possible to characterize quantitatively the probability distributions, some estimates of expected value (e.g., mean and median) must be provided in addition to ranges, variances, specified low-end and high-end percentile estimates, and other characteristics of the distribution.[67]

5. UNDERSTAND THE EFFECTS OF THE REGULATION ON DIFFERENT POPULATIONS.

THOSE WHO BEAR the costs of a regulation and those who enjoy its benefits often are not the same people. And different groups of beneficiaries might value the benefits differently.

While some government programs are designed to redistribute wealth (e.g., food stamps), others do so inadvertently (e.g., regulations that raise food prices might have disproportionate impacts on low-income Americans, or regulatory compliance might burden small businesses more than large ones). It is important to understand whether a regulation will have different impacts on different subpopulations, including those living in different regions of the country, businesses of different sizes, individuals of different ages, and people with different ethnic and socioeconomic characteristics. A good regulatory analysis should also evaluate the effects of tailored requirements for different segments of the regulated population and different regions of the country.

The OMB advises agencies, "Where distributive effects are thought to be important, the effects of various regulatory alternatives should be described quantitatively to the extent

67. OMB, *Circular A-4*.

possible, including the magnitude, likelihood, and severity of impacts on particular groups."[68] Doing so in the regulatory impact analysis presents decisionmakers with the evidence they need to make informed decisions to achieve policy goals.

6. RESPECT INDIVIDUAL CHOICE AND PROPERTY RIGHTS.

GOVERNMENT ACTIONS THAT undermine individual liberty and responsibility and do not respect private property are not likely to improve the welfare of American citizens. The Fifth Amendment of the Constitution provides that private property shall not be taken for public use without just compensation.

As economist Thomas Sowell has observed,

> The whole political system would not operate as well if the government could silence its critics. Similarly, the whole economic system would not operate as well if political control of resources replaced individual control. Both free speech rights and property rights belong legally to individuals, but their real function is social, to benefit vast numbers of people who do not themselves exercise these rights.[69]

Regulations that supplant individual preferences with regulators' preferences are unlikely to make citizens better off. Thus, it is important to understand the implications of regulatory action on individuals' ability to make their own choices and act responsibly.

President Obama's E.O. 13563 reinforced this principle, requiring that "each agency shall identify and consider

68. Ibid.

69. Thomas Sowell, "The 'Takings' Issue," *Forbes*, March 2, 1992, 60.

regulatory approaches that reduce burdens and maintain flexibility and freedom of choice for the public" and consider values that are difficult to quantify, such as "human dignity." For example, airline safety regulations enacted since September 11 have made flying more costly for consumers, and conventional economic analysis can measure the economic effects on the people who choose not to fly because of increased security hassles, or who choose to drive or take a train. But such an analysis fails to measure the loss of value experienced by the majority of persons who continue to travel by air even though it is a more personally intrusive and less pleasant experience. Under E.O. 13563, agencies should consider these costs to personal liberty and dignity as they consider regulatory alternatives.

FURTHER READING

Joshua B. Bolten. "Issuance of OMB's 'Final Information Quality Bulletin for Peer Review.'" Memorandum for Heads of Executive Departments and Agencies. Office of Management and Budget. December 16, 2004. http://www.whitehouse.gov/sites/default/files /omb/memoranda/fy2005/m05-03.pdf.

Curtis W. Copeland. *Regulatory Analysis Requirements: A Review and Recommendations for Reform*.Washington, DC: Administrative Conference of the United States, April 23, 2012. http://www.acus.gov /wp-content/uploads/downloads/2012/04/COR-Final-Reg-Analysis -Report-for-5-3-12-Mtg.pdf.

Jerry Ellig and Patrick McLaughlin. "The Quality and Use of Regulatory Analysis in 2008." *Risk Analysis* 32 (May 2012): 855–880.

Executive Order 13563. *Federal Register* 76, no. 14. (January 21, 2011). http://www.gpo.gov/fdsys/pkg/FR-2011-01-21/pdf/2011-1385.pdf.

Friedrich A. Hayek. "The Use of Knowledge in Society." *American Economic Review* 35, no. 4 (1945): 519-30.

Office of Information and Regulatory Affairs. "Agency Checklist: Regulatory Impact Analysis." http://www.whitehouse.gov/sites /default/files/omb/inforeg/regpol/RIA_Checklist.pdf.

Office of Information and Regulatory Affairs. *Regulatory Impact Analysis: A Primer*. http://www.whitehouse.gov/sites/default/files /omb/inforeg/regpol/circular-a-4_regulatory-impact-analysis-a -primer.pdf.

Office of Management and Budget. *Circular A-4*. September 17, 2003. http://www.whitehouse.gov/omb/circulars_a004_a-4/.

Michael C. Munger. *Analyzing Policy: Choices, Conflicts, and Practices*. New York: Norton, 2000.

Cass R. Sunstein. "Informing Consumers Through Smart Disclosure." Memorandum for the Heads of Executive Departments and Agencies. Office of Management and Budget. September 8, 2011. http://www. whitehouse.gov/sites/default/files/omb/inforeg/for-agencies /informing-consumers-through-smart-disclosure.pdf.

9

THE FUTURE OF REGULATION

B Y ALL MEASURES, federal government regulation of private activities is growing. In 1960, federal outlays directed at writing, administering, and enforcing regulations were $3.4 billion; in fiscal year 2013, that figure is almost $60 billion.[70] The Small Business Office of Advocacy estimates that compliance with federal regulations costs businesses and consumers $1.75 trillion per year. The OMB's compilation of agencies' ex ante estimates suggests that the benefits of economically significant regulations issued over the last decade are between $141 billion and $700 billion per year, with corresponding costs of between $43 billion and $67 billion.

The focus of regulation has changed over the last several decades, and despite this overall growth in regulatory activity, regulation of some areas has declined. Before the 1960s, federal regulatory activity was primarily aimed at controlling

70. Figures in constant 2012 dollars.

prices. Beginning in the 1970s, deregulation of many of these traditional industries has allowed market forces to take over the regulation of price and quality with marked success.

In the 1970s, the focus of regulation shifted to actions aimed at protecting health, safety, and the environment. In that decade, Congress and the presidents established a host of new regulatory agencies, including the Environmental Protection Agency, the Occupational Safety and Health Administration, the Consumer Product Safety Commission, and the National Highway Traffic Safety Administration. The budgets and regulatory reach of these agencies have grown significantly since then.

The terrorist attacks of September 2001 led to an increase in regulations aimed at enhancing homeland security. Formed in 2002, the Department of Homeland Security incorporated several existing agencies with regulatory functions. The regulatory portion of its budget has grown from $8 billion (the regulatory portion of the budget of its predecessor agencies) to $25 billion a decade later.

The passage of two major statutes in 2010 may presage a return to economic forms of regulation. The Patient Protection and Affordable Care Act authorizes the Department of Health and Human Services to issue regulations aimed at controlling the price and quality of health care, and the Dodd–Frank Wall Street Reform and Consumer Protection Act has set in motion new financial market regulations developed and enforced by newly organized agencies.

Another trend in regulation is that the global consequences of domestic regulatory policies are increasingly important. As tariffs and other explicit barriers to international trade and investment fall, differences in regulatory requirements have emerged as more significant barriers to trade than they were in the past. The agenda of the joint U.S.–EU Transatlantic Economic Council, established in 2007, includes regulatory

coordination goals such as better information-sharing on regulatory activities, risk assessment, and sector-specific coordination and mutual recognition. The U.S. government is entering into similar agreements with other trading partners, particularly Canada and Mexico, and the Administrative Conference of the United States has endorsed further actions to "promote transparency, mutual reliance, information sharing, and coordination internationally."[71] In May 2012, President Obama issued Executive Order 13609 to "promote American exports, economic growth, and job creation by helping to eliminate unnecessary regulatory differences between the United States and other countries and by making sure that we do not create new ones."[72] These initiatives recognize that, while minimizing unnecessary differences that could hinder free trade is a worthwhile goal, some regulatory competition is likely to be beneficial, and converging on poorly designed regulations will harm businesses and consumers in all countries.

While the focus of regulations is evolving, so is the process by which they are developed. The emergence of the Internet and electronic rulemaking dockets are changing the dynamics of the regulatory process. Regulation is no longer solely the purview of Washington-based lobbyists. Members of the public now have more opportunities to engage in the regulatory debate. As agency processes are made more transparent via the Internet, the once-arcane world of regulation will become more accessible to a much wider public, with the potential for making regulators and regulations more

71. The Administrative Conference of the United States is an independent federal agency comprising 101 public and private members who make recommendations to improve administrative procedure. Its recommendations on international regulatory cooperation are available at http://www.acus.gov/acus -recommendations/international-regulatorycooperation/.

72. Cass R. Sunstein, "Reducing Red Tape: Regulatory Reform Goes International," OMBlog, May 1, 2012, http://www.whitehouse.gov /blog/2012/05/01/reducing-red-tape-regulatory-reform-goes-international.

accountable to the people. Additionally, social media and other Internet technologies lower the cost of group formation and collective action so that citizens will be better able to educate themselves about the regulations that affect them and to take action to make their voices heard.

Understanding the impetus for regulation, the incentives faced by regulators and regulated parties, and the underlying market conditions that lead to regulation is essential for evaluating the consequences of regulatory actions and the legislation that enables them. This knowledge is important not only for understanding the effects of proposed new regulations, but for examining whether existing regulations are achieving their intended goals. The concepts introduced in this primer are essential to that understanding and will remain so as federal regulation continues to evolve.

FURTHER READING

Administrative Conference of the United States. *Administrative Conference Recommendation 2011-6: International Regulatory Cooperation.* December 8, 2011. http://www.acus.gov/wp-content /uploads/downloads/2011/12/Recommendation-2011-6-International -Regulatory-Cooperation.pdf.

Administrative Conference of the United States. *Administrative Conference Recommendation 2011-8: Agency Innovations in E-Rulemaking.* December 9, 2011. http://www.acus.gov/wp-co ntent/uploads/downloads/2011/12/Recommendation-2011-8-E -Rulemaking-Innovations.pdf.

Executive Order 13609. *Federal Register* 77, no. 87. (May 5, 2012). http://www.whitehouse.gov/sites/default/files/omb/inforeg/ eo_13609/eo13609_05012012.pdf.

Susan Dudley. "Prospects for Regulatory Reform in 2011." *Engage* 11 no. 1, June 2011.

APPENDIX – E.O. 12866, SECTION 1, STATEMENT OF REGULATORY PHILOSOPHY AND PRINCIPLES

(a) The Regulatory Philosophy. Federal agencies should promulgate only such regulations as are required by law, are necessary to interpret the law, or are made necessary by compelling public need, such as material failures of private markets to protect or improve the health and safety of the public, the environment, or the well-being of the American people. In deciding whether and how to regulate, agencies should assess all costs and benefits of available regulatory alternatives, including the alternative of not regulating. Costs and benefits shall be understood to include both quantifiable measures (to the fullest extent that these can be usefully estimated) and qualitative measures of costs and benefits that are difficult to quantify, but nevertheless essential to consider. Further, in choosing among alternative regulatory approaches, agencies should select those approaches that maximize net benefits (including potential economic, environmental, public health and safety, and other advantages; distributive impacts; and equity), unless a statute requires another regulatory approach.

(b) The Principles of Regulation. To ensure that the agencies' regulatory programs are consistent with the philosophy set forth above, agencies should adhere to the following principles, to the extent permitted by law and where applicable:

(1) Each agency shall identify the problem that it intends to address (including, where applicable, the failures of private markets or public institutions that warrant new agency action) as well as assess the significance of that problem.

(2) Each agency shall examine whether existing regulations (or other law) have created, or contributed to, the problem that a new regulation is intended to correct and whether those regulations (or other law) should be modified to achieve the intended goal of regulation more effectively.

(3) Each agency shall identify and assess available alternatives to direct regulation, including providing economic incentives to encourage the desired behavior, such as user fees or market-able permits, or providing information upon which choices can be made by the public.

(4) In setting regulatory priorities, each agency shall consider, to the extent reasonable, the degree and nature of the risks posed by various substances or activities within its jurisdiction.

(5) When an agency determines that a regulation is the best available method of achieving the regulatory objective, it shall design its regulations in the most cost-effective manner to achieve the regulatory objective. In doing so, each agency shall consider incentives for innovation, consistency, predictability, the costs of enforcement and compliance (to the government, regulated entities, and the public), flexibility, distributive impacts, and equity.

(6) Each agency shall assess both the costs and the benefits of the intended regulation and, recognizing that some costs and benefits are difficult to quantify, propose or adopt a regulation

only upon a reasoned determination that the benefits of the intended regulation justify its costs.

(7) Each agency shall base its decisions on the best reasonably obtainable scientific, technical, economic, and other information concerning the need for, and consequences of, the intended regulation.

(8) Each agency shall identify and assess alternative forms of regulation and shall, to the extent feasible, specify performance objectives, rather than specifying the behavior or manner of compliance that regulated entities must adopt.

(9) Wherever feasible, agencies shall seek views of appropriate State, local, and tribal officials before imposing regulatory requirements that might significantly or uniquely affect those governmental entities. Each agency shall assess the effects of Federal regulations on State, local, and tribal governments, including specifically the availability of resources to carry out those mandates, and seek to minimize those burdens that uniquely or significantly affect such governmental entities, consistent with achieving regulatory objectives. In addition, as appropriate, agencies shall seek to harmonize Federal regulatory actions with related State, local, and tribal regulatory and other governmental functions.

(10) Each agency shall avoid regulations that are inconsistent, incompatible, or duplicative with its other regulations or those of other Federal agencies.

(11) Each agency shall tailor its regulations to impose the least burden on society, including individuals, businesses of differing sizes, and other entities (including small communities and

governmental entities), consistent with obtaining the regulatory objectives, taking into account, among other things, and to the extent practicable, the costs of cumulative regulations.

(12) Each agency shall draft its regulations to be simple and easy to understand, with the goal of minimizing the potential for uncertainty and litigation arising from such uncertainty.

ABOUT THE AUTHORS

Susan E. Dudley is director of the George Washington University Regulatory Studies Center and a research professor in GW's Trachtenberg School of Public Policy and Public Administration. She served as administrator of the Office of Information and Regulatory Affairs in the U.S. Office of Management and Budget from April 2007 to January 2009. She has directed the Regulatory Studies Program of the Mercatus Center at George Mason University, taught in the GMU School of Law, and worked on the staff of OIRA, the EPA and the U.S. Commodity Futures Trading Commission.

Jerry Brito is a senior research fellow at the Mercatus Center at George Mason University and director of its Technology Policy Program. He also serves as an adjunct professor of law at GMU. His research focuses on technology and telecommunications policy, government transparency and accountability, and the regulatory process. He is the creator of OpenRegs.com, an alternative interface to the federal government's regulatory docketing system.

ABOUT THE PUBLISHERS

THE MERCATUS CENTER AT
GEORGE MASON UNIVERSITY

THE MERCATUS CENTER at George Mason University is the world's premier university source for market-oriented ideas—bridging the gap between academic ideas and real-world problems. A university-based research center, Mercatus advances knowledge about how markets work to improve people's lives by training graduate students, conducting research, and applying economics to offer solutions to society's most pressing problems. Our mission is to generate knowledge and understanding of the institutions that affect the freedom to prosper and to find sustainable solutions that overcome the barriers preventing individuals from living free, prosperous, and peaceful lives.

THE GEORGE WASHINGTON UNIVERSITY
REGULATORY STUDIES CENTER

THE GEORGE WASHINGTON University Regulatory Studies Center was established in 2009 to improve regulatory policy by raising awareness of regulations' effects through research, education, and outreach. As an academic center located in GW's highly-ranked Trachtenberg School of Public Policy and Public Administration, the Regulatory Studies Center is a leading source for applied scholarship on regulatory issues, and a training ground for current and future policy officials who want to understand the effects of regulation and ensure that regulatory policies are designed to advance the public interest.

NOTES

NOTES

NOTES